WE WALK THE EARTH IN BEAUTY

TRADITIONAL NAVAJO LIFEWAYS

Third Edition

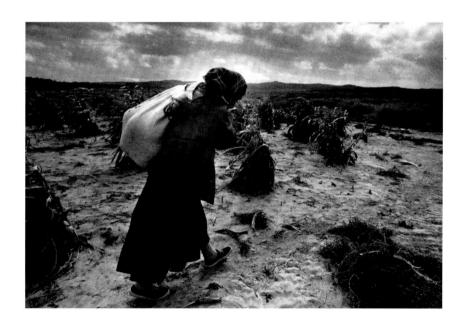

BY KATHY ECKLES HOOKER

Photography by Helen Lau Running

With a new preface by the author and a new foreword by Lisa Puente Siyuja

We Walk the Earth in Beauty: Traditional Navajo Lifeways

© 2024 by Kathy Eckles Hooker Photographs © Helen Lau Running All rights reserved. Published 2024.

Except for use in a review, the reproduction or utilization of this work in any form or by any electronic, mechanical, or other means, now known or hereafter invented, including xerography, photocopying, and recording, and in any information storage and retrieval system, is forbidden without the written permission of the publisher.

Originally published as *Time Among the Navajo: Traditional Lifeways on the Reservation*. Santa Fe: Museum of New Mexico Press, 1991 (ISBN 0890132216). Second edition Flagstaff, Arizona: Salina Bookshelf, 2002 (ISBN 1893354350).

ISBN: 979-8-9913336-0-3 Library of Congress Control Number: 2024917094

Cover design by Corey Begay Interior design by Mary Ross Design

Illustrations of plants, water, wood, animals, and soil by Bahe "Buddy" Whitethorne Jr.

Editorial services by Catherine Bell and Julie Hammonds

Text fonts: Minion Pro, Avenir Display fonts: Frankie, Badhouse

Printed in Canada by Friesens

Soulstice Publishing
PO Box 791
Flagstaff, AZ 86002
(928) 814-8943
connect@soulsticepublishing.com
www.soulsticepublishing.com
29 28 27 26 25 24 1 2 3 4 5

To the Navajo Elders

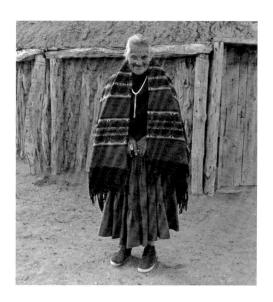

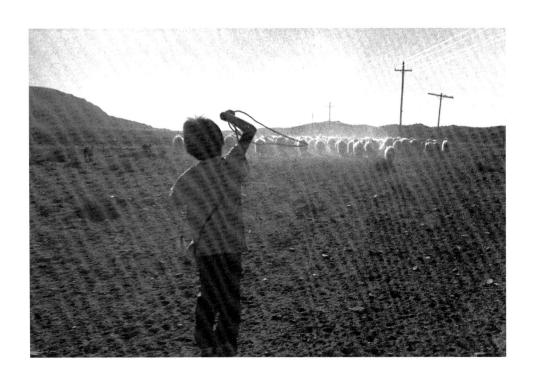

CONTENTS

PUBLISHER'S NOTE		ix
FOREWORD		×
PREFACE TO THE THIRD EDITION		xi
PART 1: PLÄNTS		
INTRODUCTION		
CHAPTER 1 YUCCA SHAMPOO	THE SPENCER FAMILY	6
CHAPTER 2 BɹÉZÓ (Grass Brush)	STELLA WORKER	10
CHAPTER 3 GRINDING CORN	ROBERTA BLACKGOAT	13
CHAPTER 4 CORNMEAL PATTIES	ROBERTA BLACKGOAT	16
CHAPTER 5 NAVAJO TEA	STELLA WORKER	18
PART 2: WATER		
INTRODUCTION		23
CHAPTER 6 HAULING WATER	DANNY BLACKGOAT	25
CHAPTER 7 NAVAJO FARMING	ELLA DEAL	27
PART 3: WOOD		
INTRODUCTION		37
CHAPTER 8 FIREWOOD.	DANNY BLACKGOAT	39
CHAPTER 9 THE CORRAL	OSKAR WHITEHAIR	40
CHARTER 10 SUMMER SHELTER	YA77IF	13

PART 4: ANIMALS

INTRODUCTION	46
CHAPTER 11 MOCCASINS	SAM WORKER 49
CHAPTER 12 BRANDING	THE DEAL FAMILY51
CHAPTER 13 HERDING	THE DEAL FAMILY55
CHAPTER 14 COOKING A GOAT	ROBERTA BLACKGOAT59
CHAPTER 15 HORSE HOBBLE	JOE GORDY66
CHAPTER 16 NAVAJO RUG	HAZEL NEZ69
PART 5: SOIL	
INTRODUCTION	80
CHAPTER 17 POTTERY	MARY JOE YAZZIE83
CHAPTER 18 MUD OVEN	ADDIE YAZZIE89
CHAPTER 19 THE HOGAN	DELBERT BEGAY91
ACKNOWLEDGMENTS	94
A TRIBUTE TO HELEN LAU RUNNING	96
LIST OF PLATES	98
NOTES	100
SUGGESTED READINGS	102
ABOUT THE AUTHOR	103
ABOUT THE PUBLISHER	103

PUBLISHER'S NOTE

We Walk the Earth in Beauty was originally published in 1991 by the Museum of New Mexico Press of Santa Fe under the title *Time Among the Navajo*. Its publication reflected a belief in the importance of preserving Navajo traditional cultural practices in book form and sharing them with Navajo and non-Navajo people alike. Salina Bookshelf of Flagstaff, Arizona, republished the book in 2002.

This book remains a singular and important reference, thanks to its careful descriptions of time-honored practices among the Navajo for doing everything from making yucca soap to building a hogan. Such methods continue to be used today, just as they were when author Kathy Eckles Hooker and photographer Helen Lau Running collected these stories and photographs in the 1980s.

In this third edition, we replaced the earlier preface and foreword. The author updated the acknowledgments and added introductory text to each of the five parts, notes, and and a tribute to Helen Lau Running. However, to reflect the original material's timeless nature, the descriptions in chapters one through nineteen remain unchanged except to correct typographical errors.

By republishing this book in 2024 under its new title, we intend to show our respect for the enduring, practical wisdom of the traditional Navajo way of life.

 Julie Hammonds and Myles Schrag, Publishers Flagstaff, Arizona

FOREWORD

Everything that surrounds us gives us life. We treat the land, water, animals, and all living things with respect and only use what we need to survive. Throughout history, the Diné (Navajo) have learned how to live off the land and provide for their families. Seasons come and seasons go, but the Diné know how to adapt. We carry within us a deep understanding, connection, and respect for our land.

I recall many childhood memories of my maternal grandmother, Stella, who would herd sheep, and her husband (my maternal grandfather Enrique), who would plant corn in the field. Through them, I witnessed that connection to Mother Earth and all the processes that need to take place.

This book captures the essence of such stories of Diné families who continue this sacred relationship with Mother Earth. All the wonderful gifts define who we are and how we nourish our traditional values in the modern world. Although years go by and life-changing events occur, the Diné adapt, reconnect, and lean on that relationship to recenter themselves with Father Sky and Mother Earth.

- Lisa Puente Siyuja, Director of the Hualapai Education and Training Department

PREFACE TO THE THIRD EDITION

When I lived on the Navajo Reservation beginning in the late 1970s, I taught at a local boarding school. I was fortunate to develop a rapport with my Navajo students. They shared about their home lives, telling me where they lived, what their camps were like, and the kinds of food they ate. Once, I asked a student what he had done over the weekend. He said, "I hunted prairie dogs, cooked them, and ate them for dinner." To him it was a report of an ordinary occurrence; to me it was a surprise. Having grown up in suburban Washington, D.C., I had never hunted for a meal.

Curious about their way of life, I asked my students to make a list of traditional Navajo tasks practiced by their families. The final list included building a hogan, making yucca shampoo, hauling water, cooking Navajo blood cakes, and grinding corn. The students were amused at my lack of knowledge about their lifeways, so for the next month, these young people dictated oral histories covering specific traditional Navajo methods. I recorded these methods in book form and presented the books to the students at the end of the school year.

Listening to my students, I learned of their families' close relationship with the earth and their capacity to exist within the dominant American society and still hold on to their traditional lifeways. I was drawn to those who maintained this life, which was not a choice but a continuation of practices from past centuries. This minority culture, keeping to its ancestral ways, existed as something of an endangered species within the dominant society. And yet, for many Navajo these traditions remain constant.

After living on the reservation for almost three years, I moved to Flagstaff, Arizona, to continue teaching. Even though I left the reservation, my longing to learn of Diné culture remained. I wanted to document The People in action, and I needed a photographer who carried the same vision. Fortunately, I found Helen Lau Running. Together we planned to record, through writing and photography, Navajo traditional lifeways.

In the early 1980s, Helen and I contacted the Navajo people we knew throughout the western reservation. Surprisingly, we found many who were willing to teach us their "old ways." Setting up their visits was hit-or-miss. I would talk to one Navajo friend who might know of another who could show us how to make a *béézó* (grass brush). In turn, the woman who made the brush might know of someone who would be willing to make pottery for us, or another who would weave a rug. Because many Navajo had no telephones and collected their mail from a trading post once every two weeks, communication between us was neither swift nor certain. We sent letters and hoped they were received.

It was difficult to locate Navajo camps on our own, since most traditional camps lack a street address. Some family members waited in their trucks at a designated mile marker on a paved reservation road as a meeting spot. Acknowledging us with a head nod, the driver would lead us on a dirt road to their homestead. However, when others spotted us coming, they would start their engines and take off so fast we would lose them! Fortunately, we found other camps, and a family member would lead us to the correct residence. Our most successful method of locating people was when an adult son or daughter who lived in Flagstaff would ride with us to their parents' camp, usually a 100-mile drive.

Dirt roads accessed most of the reservation, and when snow arrived and then melted, the roads transformed into thick sludge. Getting stuck for hours or sometimes for a day was common. After a snowstorm, Helen and I left Flagstaff long before dawn, hoping the reservation roads would still be frozen. When it came time to return to Flagstaff, we waited late into the evening or left before daybreak to be greeted with frozen roads. We breathed a sigh of relief when our tires finally hit paved highways.

We sensed our visits would be awkward; Helen and I were strangers to The People. Our concern for being turned away was real and, we learned, needless. We were welcomed with soft Navajo handshakes.

One of our first visits was to the Deal camp. Ella Deal, a tall, slender grandmother, had lived near the Hard Rocks area all her life. Leonard, her husband, was a short man with a rugged face, weathered from the dry Arizona climate. The Deals maintained the seminomadic existence of traditional Navajo people and were

known for the garden they tended in a valley close to their summer camp. Ella planted a large garden each spring. That year, Helen and I watched the plants mature through the summer and on into the harvest.

Ella acted as the liaison for many of our contacts. Her friend Oskar Whitehair lived in a pink cinderblock house in Cactus Valley. Ella introduced us to Oskar, who spoke about his large and intricately woven corral. After his explanation of how to construct the corral, he invited us to walk to the field to help bring his sheep back for the evening.

Ella's sister, Hazel K. Nez, a well-known rug weaver, lived about two miles from the Deal's camp. Hazel agreed to weave a rug. From shearing to washing to carding and spinning to finally weaving, it took four trips to Hazel's camp to observe the rug-weaving process. At her loom, her legs were crossed and her back and shoulders were rounded as she would weave. She remained in this position hour after hour as she wove inch after inch of the rug. Once it was completed, Hazel stood up slowly, complaining of stiff legs, but her face radiated a big smile. She carried the rug into her home and placed it across her bed. With a brush, she moved the bristles back and forth to clean the rug thoroughly. She folded it neatly and handed it to me. I gave her eight fifty-dollar bills. She took the money and declared, "I weave today, and I will sleep tonight!"

Hazel's close friend was Roberta Blackgoat, a hard worker who lived alone in Big Mountain, Arizona. Roberta's days were spent chopping wood, hauling water, weaving, herding sheep, and grinding corn. She had a motherly concern for her animals. One chilly spring night, Roberta was worried about the sheep she had sheared, fearful the animals would become cold. Not able to sleep, she rose at three o'clock in the morning to put a burlap bag around each animal for warmth. "I put sweaters on them," she explained.

Roberta's son Danny Blackgoat lived in Flagstaff and traveled to his mother's camp monthly. "Coming back to my mom's place fills me up inside." Roberta has lived her whole life in the Big Mountain area. One March morning, Danny traveled to her home to make sure she had plenty of wood and water, two necessary resources for Roberta's survival.

Mary Spencer, who lived in the southwestern portion of the reservation, not far from Winslow, Arizona, spoke Navajo exclusively and used her son Bruce, who lived in Dilkon, as a translator. Like many Navajo, Mary, a widow, had lived on the land her entire life. The tribe recently built her a new hogan with a tile floor and drywall panels. Even though Mary enjoyed the comforts of her modern hogan, she still lived the traditional way. We had come to learn how to make yucca shampoo. Mary assumed her role as teacher and lectured us in Navajo. We turned to Bruce for translation, and he took the cue and explained her instructions in detail.

Ella led us to Delbert Begay, who was in the process of building a hogan for his mother. This contact was important to us, as partially built hogans are difficult to find. Initially, we were led to believe that Delbert spoke no English. We asked questions, and he stared back without a response. One of his children offered translation. In this way, Delbert listed in Navajo the materials necessary to build a hogan and the process involved in its construction.

A few weeks later at a nearby trading post, Helen and I heard a man call to us, "Hi! Hi! How are you?" In clear English, Delbert asked how our project was going. We spoke together for about twenty minutes. We realized that we had proved ourselves to Delbert, because he had chosen to communicate with us in English.

The husband-and-wife team of Sam and Stella Worker provided instruction in the making of moccasins by Sam, and Navajo tea and a *béézó* by Stella. As we pulled up to their camp, we noticed their small hogan, the blue sky above, and the snow-covered San Francisco Peaks in the distance. The view was spectacular. As we approached the hogan, we could hear the thump, thump, thumping of Stella's weaving tools tapping yarn into a rug. We knocked at the door, heard a faint, "Come in," and entered. Stella, a plump woman in her sixties, sat crosslegged at the loom. Sam was nearby, sorting through his moccasin-making tools. After a greeting and settling-in time with the couple, Stella instructed her husband in Navajo that it was time to make the shoes.

One of our later contacts was Mary Joe Yazzie, a friend of Ella's. Mary Joe was a single parent in her forties who worked for Peabody Coal and made pottery with whatever spare time she had. We traveled with Mary Joe to a pit near her home

to dig for clay. For the second ingredient, we visited a piñon forest to gather pitch. "Our luck this day is good; the sap is flowing," said Mary Joe. "I can't believe it! Sometimes we would come to the piñon trees and look all day and find nothing!"

We spent just a short time with some of our contacts. Joe Gordy, father-in-law of Mary Joe, made a horse hobble. Yazzie, a soft-spoken young man in his twenties who lived traditionally, was knowledgeable about materials for building hogans and summer shelters. He took us to his mother's mud oven. Addie, mother of Yazzie, was an elegant woman who spoke Navajo exclusively. She smiled, giggled, and nodded as her son spoke.

At the project's end, I saw a common thread. Each topic in some way related to the land. They fell easily in the five categories of plants, water, wood, animals, and soil. Stella Worker's Navajo tea and *béézó*, Roberta Blackgoat's corn grinding, and Mary Spencer's yucca shampoo all came from plants from the reservation. Danny Blackgoat and the Deal family showed the uses of water; Danny hauling it for drinking, and the Deal family watering their garden. Danny's firewood, Yazzie's summer shelter, and Oskar Whitehair's corral used the resource of wood. From the animals came Joe Gordy's horse hobble, Hazel Nez's beautiful woven rug, Roberta Blackgoat's Navajo blood cakes, the Deal family's cattle branding, and Sam Worker's moccasins. The earth itself is found in Addie Yazzie's mud oven, Delbert Begay's hogan, and Mary Joe Yazzie's pottery.

Throughout our travels on the reservation, it was meaningful to witness the close ties of families and friends, along with their relationships with their land and animals. As Danny Blackgoat noted, "With the sky above, we Navajos are the walkers of the earth, and we know we are one with it." His words still ring true today. The traditional lifeways these generous people shared with Helen and me remain timeless. I'm grateful to have witnessed them and to share them with you.

Charles and the Market Section of the Conference			en takka ter	
	entropies (Company) in the company of the company o			

PLANTS ARE ONE OFFSPRING OF THE EARTH MOTHER AND SKY FATHER. UTILIZED TO PERPETUATE LIFE, THEY ARE SYMBOLIC OF THE ESSENCE OF LIFE.—STEVEN A. DARDEN

NAVAJO RESERVATION PLANTS SUPPLY FOOD, DRINK, UTENSILS, SOAP, medication, and dyes for the Diné. "Wild native plants contribute many varieties of fruit, edible flowers, seeds, pollen, bark, and roots." Yucca, Navajo tea, sagebrush, four-wing saltbush, and rabbit brush are the most common. Navajo people supported the growth of corn, beans, squash, and other vegetables with developed irrigation systems long before the arrival of the Spanish.

A yucca plant gives a variety of goods, from the top of its sharp, pointed tips to the bottom of its white roots. Briskly rubbing its roots in water causes a thick, sudsy lather to form, which is used for washing hair, clothing, bodies, and sheep's wool. A weaver mixes a pounded yucca root and water to produce suds, which she pours over the wool so the dirt can be removed.² The best root-digging times occur after a rainstorm or snowmelt softens the soil. The sturdy, thick leaves create sandals, baskets, and small ties, while its sharp tips can be used as needles.³ For medicinal purposes, Navajo people rub yucca soap on leaves and place them on their skin to heal skin sores and open wounds. Its leaves act as a Navajo version of a Band-Aid.

Most Navajo land exists in the elevations of 5,000 to 7,000 feet in the steppe vegetation region where grasses, sagebrush, and piñon and juniper grow.⁴ Long before the arrival of the first Europeans, Southwest natives created a versatile tool from a grass called sandhill muhly, which

can grow from four to twenty-four inches.⁵ In the Navajo language, this utensil is called a bé'ézó, or grass brush. Often growing near sandy areas and harvested in the fall, it is used by The People for brushing, cleaning, and as a sieve in the kitchen. They pick the grass in bunches and tie them together in the center using a yucca leaf.

Another gift produced by Mother Earth is the herb called cota, greenthread, or Navajo tea. Harvested in early summer and fall from flower buds, the tea is made from slender leaves resembling threads, which are bundled and steeped in boiling water. The greenthread herb has been assigned the scientific name of Thelesperma megapotamicum and can grow to a height of over one foot. This caffeine-free tea "has a flavor comparable to normal green tea, but it also has a nice aromatic flavor." 6 Because it is a drink for many native tribes, the beverage has several names, like Hopi tea, pueblo tea, cota tea, Zuni tea, and desert tea. Others call it Navajo cola. When a tea drinker snaps a stem close to the soil and shakes the plant, it releases the seeds back to the soil for more plants to grow.⁷

Corn, known as a sacred plant, brings sustenance to The People. This vegetable, an ancient mainstay of Native Americans, first grew in Mexico and spread throughout the American Southwest. Natives were successful in discovering how to grow corn in the Southwest's arid environment.8 The Diné prepare many corn dishes, such as tamales or kneel-down bread, corn pancakes, blue-corn mush, and steamed-corn stew.

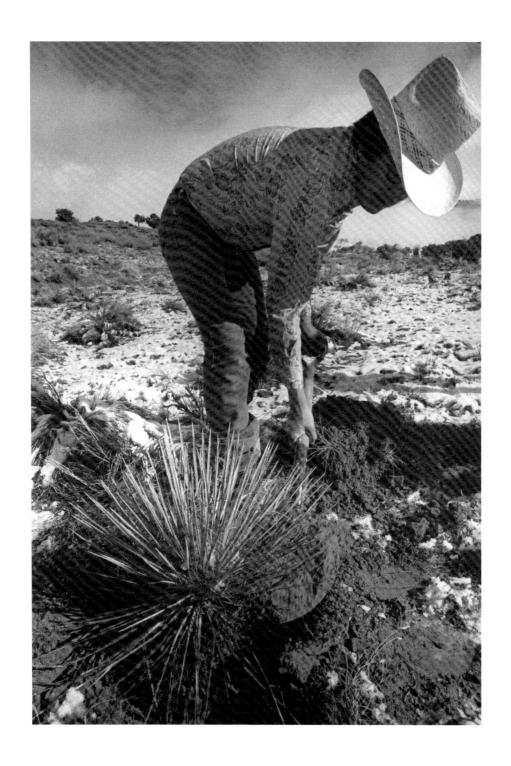

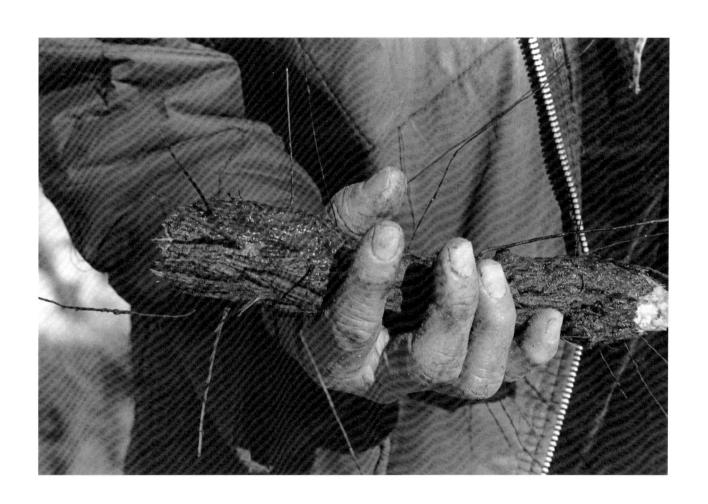

CHAPTER ONE

YUCCA SHAMPOO

MARY SPENCER PLANS TO WASH HER GRANDDAUGHTER

Lisa's hair in the Navajo way, using yucca from her land. Mary, her son Bruce, his wife, Alice, and Lisa drive into the hills close to Mary's camp to find a fresh yucca. "Old yucca is just no good," Bruce says. "It sure gets rotten. New ones are the best and make good soap, and I'm sure there is one around here." He finds a young yucca within moments.

Shovel in hand, Bruce carefully digs up the soft soil around the plant. With one tug, he pulls out the yucca, exposing its muddy root. Holding the plant in place on the ground, he chips the root off with his shovel blade. As Alice and Lisa return the plant to the soil, Bruce shovels dirt around it, explaining, "We always give the yucca back to the land."

Mary cleans mud from the root

by rubbing it briskly on some damp pop of white bubbles grass nearby. Over and over, she around her ears. wipes the root until it is only a small stick with bark. From the size of the root, the women decide they have enough for one quiet pop washing. Mary returns to camp, leaving land that few minut looks as if it has never been touched. it is time to

Bruce begins the soapmaking process by cracking the root with a hammer to break the bark-covering shell. As he removes the shell, a white root emerges that is fibrous, slick, and soapy. While a large pan of water warms, Mary

emphasizes that "the pan and your hands have to be clean, not greasy, or the yucca won't work—it won't make soap." The results, it is clear, will be worth the effort. "I've used yucca on my hair all of my life, and I like the way it works."

In a large metal bowl, Mary splashes water over the clean root, producing a thick, white lather. Mary rubs the root as if it is a bar of soap,

> and gentle bubbles begin to form. As the bubbles change into thick suds, Mary continues the rubbing. After a few minutes, the bowl overflows with lather.

Lisa unties her long, black ponytail, bends over, and lowers her hair into the lather. Her grandmother scoops up the sudsy water and washes it into Lisa's hair. Mary massages her granddaughter's scalp, working the yucca suds gently through the black strands. Lisa says she loves the soft rubbing of her grandmother's hands on her

head, and also hearing the swish of water and the quiet pop of white bubbles around her ears. After a few minutes, Mary tells Lisa her hair is clean, and it is time to rinse.

Alice hands another pot of warm water to Mary, who slowly pours it over Lisa's soapy head. The rinsing takes several minutes, but soon the girl's wet hair shines. Alice squeezes her daughter's hair with a towel, and when she

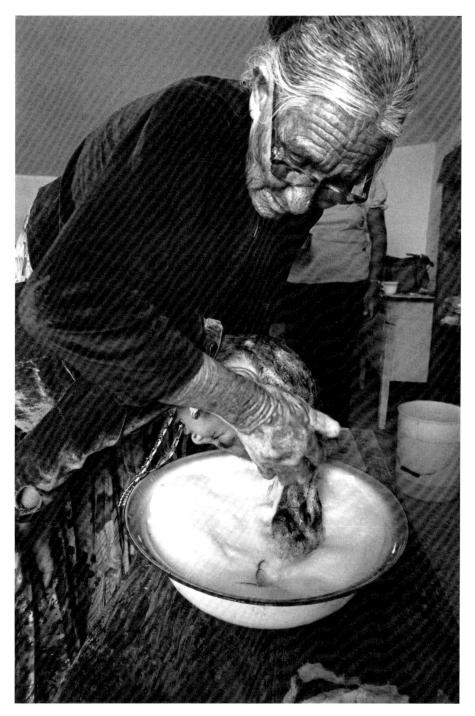

"Yucca makes hair shiny, and it makes hair grow longer." - MARY SPENCER

removes the wrapping, Lisa throws her head back so that her long hair first flies up into the air and then flops down on her back. The few yucca fibers sticking to the strands of hair drop to the floor as Lisa shakes her head from side to side, bouncing her hair in a hair-drying dance. She moves close to the fire to allow its warmth to reach her hair.

"That soap from the store gives you dandruff. This yucca doesn't," Mary explains. "It makes hair nice. Some people can get a rash from it, but most Navajos don't. Yucca makes hair shiny, and it makes hair grow longer."

To finish the hairdressing tasks, Mary brings out a brush called a béézó, carefully removing it from the bag in which it is stored. The *bé'ézó* is a bundle of stiff, dried perennial grass called sandhill muhly that grows near sandy areas. "We pick the grass in August and September, after it has been dried by the hot summer sun," explains Alice. Mary takes the *bé'ézó* and lightly hits the ends against the palm of her hand. Over and

over, she taps the grass ends to make them even. Lisa kneels close to her grandmother as Mary combs the now-dry hair first with her fingers. Cradling the hair in her hand, she begins the brushing, while the *bé'ézó* makes scratching sounds against Lisa's head. Soon her long hair becomes straight and glossy.

The final step is the Navajo hair bundle. Mary pulls Lisa's hair back over her shoulders, takes a hank of white yarn, and wraps it once around the hair to make an ordinary ponytail. Next, the ponytail is folded three times until it reaches the scalp to form a long, double loop of hair. She wraps the yarn tightly around the center of the loop of hair, then fans out the hair above and below the tie to form two full bundles. Mary looks at Lisa with approval.

Grandmother and granddaughter sit side by side. Mary Spencer's face has the beauty of age and experience. Lisa's is young and attentive. She now has the knowledge of the yucca and will one day teach her children how to use it.

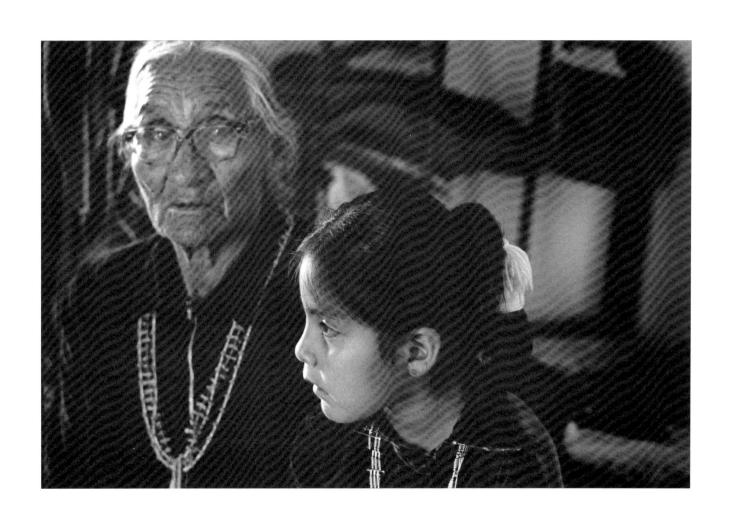

CHAPTER TWO

STELLA WORKER TAKES PRIDE IN SHOWING THE TOOLS she constructs, such as her béézó, which she makes every fall. "It's the best time of year," she explains. "The cool weather makes the stems hard and good for brushing, cooking, and cleaning."

Navajo women pick the grass for their brushes in bunches and bind them together with string, cloth, or yucca leaves. Once bound, the béézó is one foot to two feet in length and one to two inches in diameter. The sweeping end of the brush is coarse, while the other end is "This is the oldfull and bushy.

One clear October day, Stella hikes fashioned Navajo over the hill by her hogan to a bé'ézó way. I still use picking place, a meadow full of sage these brushes and sandhill muhly. Once there, she sits today because down with legs sideways, spreads out her they work really, skirt, and picks a *béézó* bundle. Her fingers break the culm (stem) close to the ground really well." and pull each sheath away. She puts the clean stem stalks on her skirt. At one point, she stops to feel the stiff ends of the grass. "It makes a pretty good brush." Stella resumes her picking and cleaning until her skirt is full. She scoops up the grass with one hand and taps the ends against her palm to make them even. "I am almost finished. All I need to do is tie the grass together."

Close to the sandhill mully is a dying yucca plant that easily yields its leaves. Stella chooses a long, thin leaf and ties it a few inches up from the base of the brush. "Sometimes I use cloth or a rubber band to keep the grass together, but I think the yucca leaf does the best job." Stella binds the

grass tightly and looks at the loose leaves that hang from the brush top. "Now all I have to do is clean off the *bé'ézó* by sweeping it across a nearby plant." With a quick, sure motion, she brushes the *bé'ézó* over a thorny bush, and the leafy parts fall to the ground. Stella holds up the brush and explains, "Good! I have a nice fat one!"

Back in her hogan, Stella is eager to begin her *béézó* demonstration. Holding the *béézó* she announces, "It is good for dusting. We take the

> soft end and flick it on the dust." Stella rapidly brushes the dust from her table, saying, "It does the job!"

> The brush is also useful in cooking. "You can use it as a spoon to stir the cornmeal, and you can use it as a broom to sweep your stones after grinding the corn." She strokes the coarse brush over her metate, and its stems scrape the stone clean. "It also

makes a good sieve. We use juniper ash water when we make cornmeal patties. The brush is spread apart and keeps the juniper ash in and lets the juniper water through."

Admiring her newly made bé'ézó, Stella reflects on the tradition of their making. "I make these brushes for many years. My mom would herd sheep, and we would bring these brushes home. A long time ago, when there were no white people's stores, this kind of brush is what all The People used. This is the old-fashioned Navajo way. I still use these brushes today because they work really, really well."

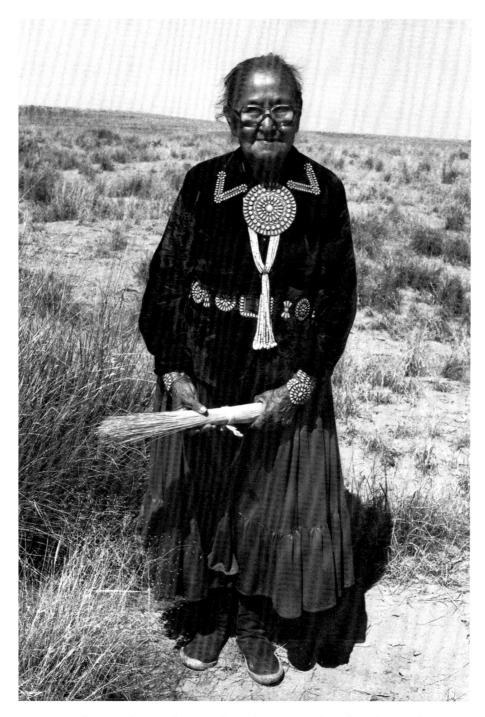

"The cool weather makes the stems hard and good for brushing, cooking, and cleaning." – STELLA WORKER

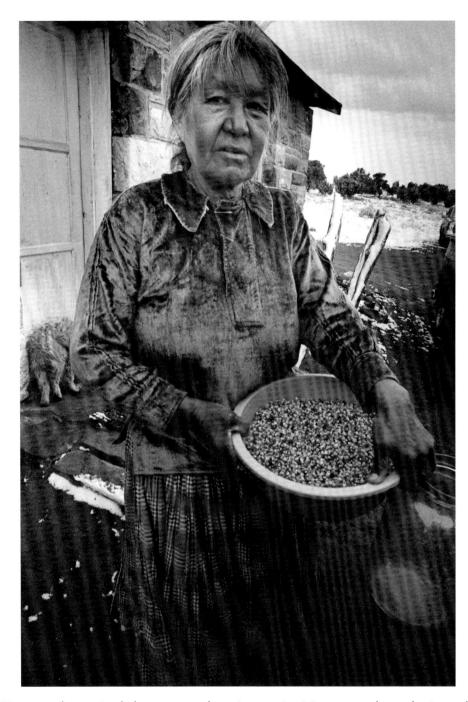

"I started to grind the corns when I was six. My aunts thought I ought to be a corn grinder and to learn this grinding way." - ROBERTA BLACKGOAT

GRINDING CORN

Roberta Blackgoat decides it is time to make cornmeal patties because she feels hungry

IN HER ROCK HOUSE LOCATED ON BIG MOUNTAIN IN ARIZONA.

for them. Making cornmeal patties is a timeconsuming task, so Roberta carefully arranges the ingredients in an organized fashion. First, she lines up all her cooking tools: goat hide, metate, mano, and brick. The metate and mano are traditional stones Roberta uses for grinding.

Both are smooth and rounded; the metate is

large and rectangular, while the mano is smaller and oblong. "You can make patties with corn that has been ground once, but I want this cornmeal to be as fine as possible, so I regrind it again, and it becomes better." Roberta turns toward her kitchen shelf, takes a canning jar full of ground, lavender-blue cornmeal, and piles it close to the stones.

Every part of the process appears a Navajo tradition. easy and natural. Roberta spreads the goat hide on the floor with the fur-side down. A brick hides under the goat skin to raise one end of the metate. Roberta positions the metate carefully so no sound is made when it touches the goat hide. She then sets the mano in the metate's concave area for stability. The metate is the base, and the mano is the grinder. Held firmly in two hands, the mano is pushed back and pulled forward over the corn kernels on the metate. Roberta and the two stones embody the act of corn grinding in terms of rhythm and movement.

The metate and mano have been in her family for many years, and both stones have been used so much they are significantly worn. "I have these stones a long time. These were my uncle's. He made them. He grew lots of corn. After he died, they went to my aunt. Then she got too old for them and didn't grind corn anymore. She gave them to me thirty years ago when my son Danny was little." Roberta adds, "I started to grind the corns when I was six. My aunts thought I ought

to be a corn grinder and to learn For fifty-five years, this grinding way. They used to Roberta has been hide me in a small hogan. They making cornmeal. wanted me to hide and grind all day long, but the policeman would She loves the come and look for me. He said grinding of the corn I was supposed to be in school." and the scraping Roberta liked school—but she also sounds of the stones liked being "good with the corns." as she continues

As Roberta works, fine cornmeal drops slowly, steadily building a lavender mound at the

base of the stone. When she finishes, the entire jar of blue cornmeal has been reground. The pile sits high on the goat skin. With a bé'ézó, she sweeps the remaining ground meal from the metate onto the mound. The hide glistens with the rich, lavender-blue color. Roberta scoops up the meal with her hands, drops it into a white bowl, and then sits back on her heels to rest.

"There is lots you can do with this meal. I can put syrup or sugar in it and make a sweet tamale corn pancake; I can add hot water to make cornmeal soup or make flat pancakes and fry them; I can mix fat and boiling water, then drop in cornmeal and stir. It makes a good, lumpy soup. Sometimes I mix mutton, water, and cornmeal," Roberta explains proudly.

For fifty-five years, Roberta has been making cornmeal. She loves the grinding of the corn and the scraping sounds of the stones as she continues a Navajo tradition.

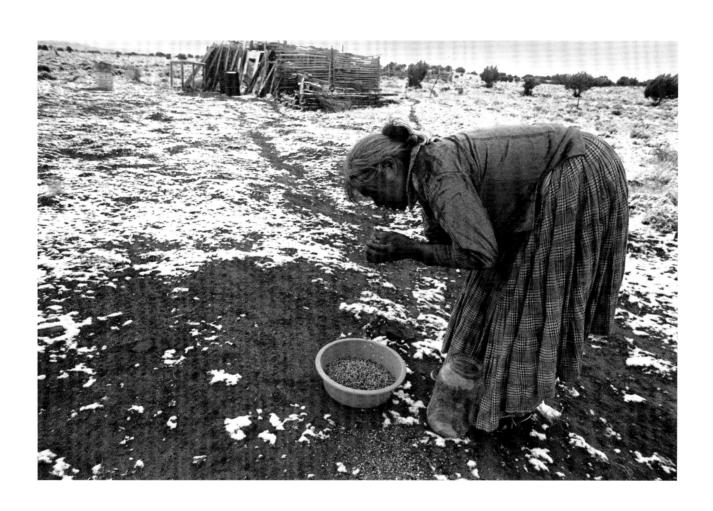

CHAPTER FOUR

CORNMEAL PATTIES

She takes a

fist-sized ball of

dough, squeezes

it between her

palms, and forms

a thick patty. After

her moistened

fingertips have

rounded the edges

of the patty, it is

ready for the hot,

oiled skillet.

EVENING SETS IN. OBSCURING THE FALLING SNOW.

The wind is blowing fiercely, but inside the rock house, a warm fire crackles in Roberta's woodburning stove. She exclaims, "My grinding from this afternoon will pay off this evening." She begins to gather the ingredients for cornmeal patties: the cornmeal she reground this afternoon, a pan of hot water, and a bowl of saltwater. Roberta picks up a shovel and goes outside to a fire pit, where she lifts snow from the ashes and extracts a clump of juniper ash. All the while, the snow swirls around her. When she returns, snowflakes cling to her hair, face, and clothing. They melt quickly, though, in the warmth of her rock house. Roberta places the ashes on her stove to warm and says, "I'll mix this ash with the blue cornmeal because it is important for my patties. It helps to keep the patties' blue color and to make them get big." Juniper ash is her leavening.

Roberta scoops two handfuls of blue cornmeal into another white mixing bowl. With her finger, she neatly taps a small amount of the juniper ash. Using the stick side of the *béézó* as a spoon, she stirs the cornmeal and ash. She explains, "Now I'll mix the leftover ash with hot, hot water. I call this mixture ash soup. I'll

pour the clean ash water into the bowl. I use my $b\acute{e}\acute{e}z\acute{o}$ as a sieve to pour the clean ash water through. When this mixture gets kind of cold, I'll make the food."

She mixes the dough, tests it, and says, "It feels a little too soft. I'll have to add more

cornmeal...now it is okay." Her mixture resembles lavender clay. She takes a fist-sized ball of dough, squeezes it between her palms, and forms a thick patty. After her moistened fingertips have rounded the edges of the patty, it is ready for the hot, oiled skillet. "In the old days, my family used a rock to cook on over the fire. I used to have one, but it broke, so now I use the skillet."

Roberta shapes the remaining cornmeal patties. Soon the skillet holds five cakes. After browning them on both sides, she puts the

patties in the oven for fifteen minutes to cook all the way through; then she removes them to cool and dips them into saltwater, explaining that the salty flavor enhances the taste. Holding a cooked patty in her hand, Roberta says, "These cakes are good. If you eat these, you won't get hungry. I keep some in my pocket when I herd sheep. This is good old-time food."

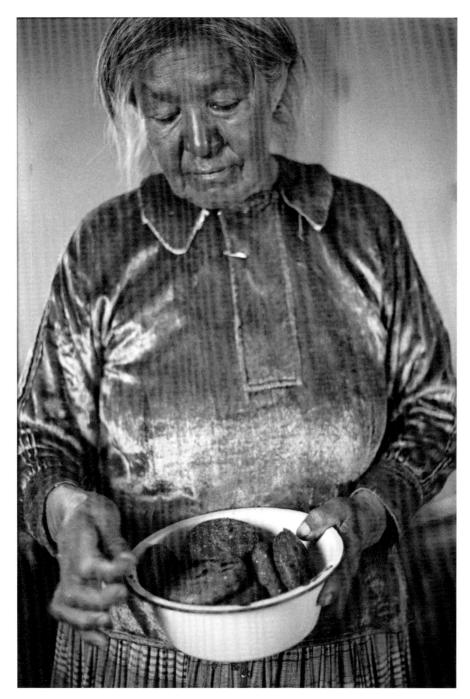

"These cakes are good. If you eat these, you won't get hungry. I keep some in my pocket when I herd sheep." - ROBERTA BLACKGOAT

CHAPTER FIVE

NAVAJO TEA

STELLA WORKER ENJOYS QUIET MOMENTS IN THE FIELDS that surround her hogan. "I like to be outside with nature, walking the land." With her everpresent smile, she says, "My family and I come out here to the land for lots of things. Whatever I want or need, I can have. It is all right here."

On this summer morning, Stella will brew Navajo tea. Made from the plant known as greenthread, Navajo tea, or cota (*Thelesperma megapotamicum*), which grows abundantly on the reservation, this tea is said to be quite flavorful. Although the stems of the plant are usually four to twelve inches long, with small leaves sprouting from the tops, only the leaves and stems are used for the tea.

Stella searches along the road

leading to her camp. She lingers in one spot for a short while in hopes of finding the plant. Without luck, she moves slowly on, explaining that "in the old days, when I was a little girl, we walked step by step with the sheep and looked for the tea. My eyes had to sort around the weeds to find it.

Sometimes the tea tried to hide from me, but I always found it. These days my eyes aren't too in a gurgood, so it is harder for me to find the plant." She pat

She continues her slow pace, squinting, until she spots a cluster of plants in a grassy spot near a yucca. Smiling, Stella moves quickly toward the Navajo tea plant and uses her finger to carefully snap the plant stems. When she holds a bundle of seven plants in one hand, she declares, "It doesn't take much to make a good pot of tea."

Back at the camp, Stella fills a large pot with water and places it on her stove. Initially she

is very talkative, but soon she becomes absorbed by her work, lapsing into silence as she cleans each individual leaf and stem. When the water on the stove boils, Stella drops the plants into the pot, noting that "Navajo tea must cook awhile."

Ten minutes later, the pink tea is deemed ready to drink. Steam rises from the pot, and bright green stems float to the surface. Stella adds two teaspoons of sugar and stirs it into the tea. She lets it cool slightly and pours some into a cup.

"I like this drink," she says. "Many women like it for their kids, to prevent them from drinking too much pop and coffee. I drink it year-round. Some people come and pick the tea and make a bundle of it. They dry it and put it in a gunnysack to use all winter. I do that too." She pats her stomach. "This sure hits the spot. I love it. It's quick and easy and comes from our land."

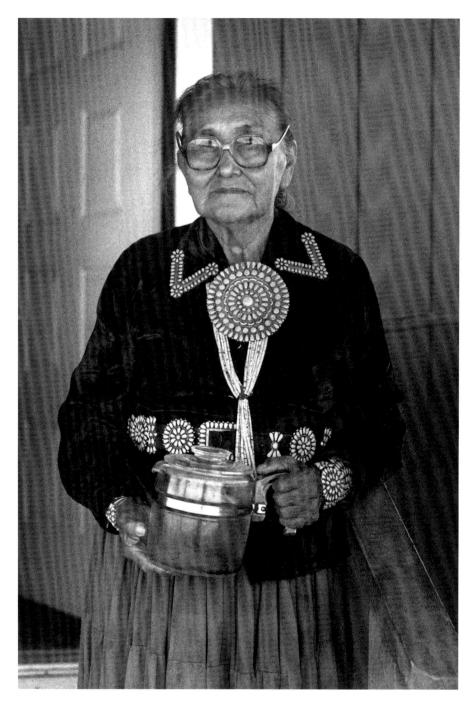

"It's quick and easy and comes from our land." - STELLA WORKER

PART

2

WATER

FATHER SKY EMBRACES MOTHER EARTH, MUCH AS A HUSBAND HIS WIFE. WATER FLOWS THROUGHOUT THE WORLD AND EMBRACES THE EARTH, PROPAGATING LIFE.—STEVEN A. DARDEN

THE NAVAJO UNDERSTAND THAT WATER IS A PRECIOUS RESOURCE

and should be used sparingly. Rainfall is scarce on the reservation and comes mostly in the summer, averaging six and a half to twelve inches a year. Drought periods are common. Thirty percent of Navajo families are without running water. Navajo people living on the reservation restrict their consumption, using eight to ten gallons of water a day, which is about a tenth of what the average American uses. Out of great concern, the Navajo Nation plans to create regional water supply projects to address this lack of water. These areas include the Ganado Regional Project, the Utah Project, and the Southwest Navajo Regional Project.

Families drive as far as fifteen or more miles with barrels in the back of pickup trucks to carry water from springs and water stations. Once home, the Diné store their water in metal or plastic barrels close to their hogan or house. One barrel lasts two to three days. Water also comes from windmills, natural springs, and wells. The water is used for drinking, handwashing, cooking, cleaning, and animal care. The People bathe by bringing buckets of water indoors and using washcloths to wash their bodies. Those without running water own outhouses and go to laundromats.

During the summer months, the Diné tend acres of growing squash, corn, potatoes, and beans. When the weather is dry, they must water their crops daily by pouring a bucket of water on each plant. Navajo people deem this a time-consuming and labor-intensive method but find it successful. By the fall season, they have a harvest. They are grateful for every barrel of water they transport.

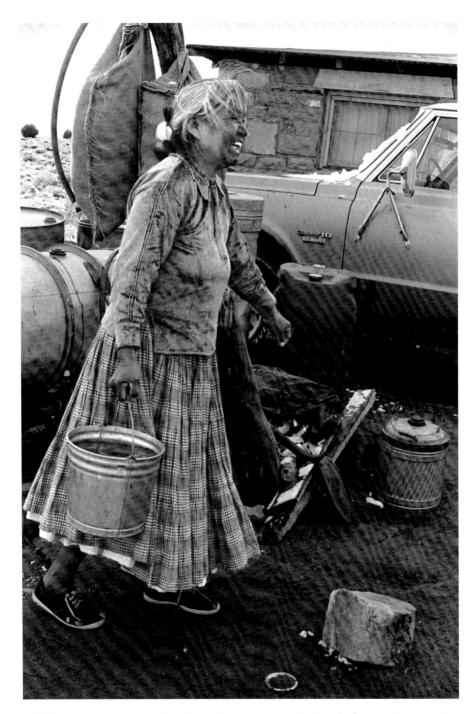

"Use a big pan under the drum to catch the leftover [water]. I'll use it for washing—every drop." - ROBERTA BLACKGOAT

CHAPTER SIX

HAULING WATER

THE COMMUNITY WELL THAT HOLDS THE WATER SUPPLY is in Blue Canyon, four miles from Roberta Blackgoat's camp. The well sits in the center of rough tracks that resemble a wheel with many spokes, each leading to a different homestead. Roberta must haul her water from this well or else from a spring eight miles from her camp, storing it in metal drums near her rock house and hogan. This is a difficult task, so she uses the water only when necessary.

"There," he says. Roberta's water drums are filled "Now we will have once a week; today her son Danny who lives in Flagstaff will make a water for a while." haul. First, he empties the remaining With this task water from one drum to another. completed, he drives "I'm doing this pouring so the drum slowly to Roberta's, will be light, and it will be easier to put into the truck." As the water promising he will take splashes into the drum, some of it it easy on the bumps, accidentally spills onto the ground. careful not to Roberta sees water wasted and, spill a drop. with some exasperation, says, "Son, watch out for it! Use a big pan under the drum to catch the leftover [water]. I'll use it for washing—every drop."

After Danny loads the empty drum into the back of his truck, he approaches a deserted camp where the logs of a hogan lie scattered on the ground. Danny explains that this is one of many old Blackgoat camps. His family has moved numerous times in search of better grazing areas for livestock. "This is something we Navajos do.

We follow our sheep. They need new grass, and so we have three or four camps spread out on our land. In spring, we take the sheep to our spring camp—the same for summer and fall. This way our sheep will have plenty to eat."

A few miles from the old camp, Danny points to another abandoned hogan. It is the place where he was born. Near the hogan spot is a large rock pile, the remains of what was once a

> make-believe fort for Danny. "We played cowboys and Indians there."

> Clouds cast shadows on the bare rock walls of Blue Canyon. The community well is covered with sandstone, and a pipe extends from its base ten feet into the air. Danny backs the pickup under the pipe, attaches the hose from the pipe to the barrel, and turns on the water. In ten minutes, the container is full. "There," he says. "Now we will have water for a while." With this

task completed, he drives slowly to Roberta's, promising he will take it easy on the bumps, careful not to spill a drop.

Back at camp, Danny uses a black rubber hose to siphon water from the drum on the truck to one on the ground, which takes very little time. Roberta is pleased. "Now we have water to drink, cook, wash, and share with the dogs."

When the community well runs dry, Danny travels to a mountain spring eight miles from his mother's camp. "It's very comforting to know we'll always have a supply of water. We're lucky. When our well is dry, we can go to the spring. It always has water. We sometimes bring our sheep here to water. We're allowed to cross another's land in order to take our sheep and goats to drink. In the old days, we would race against our sheep to see who would get to the spring first. My brother and I would always win. Then the sheep would come baa-ing over the hill. They would drink to get cool, and we would pour water over our heads. The sun was very, very hot on the sheep and us.

The water was very, very cold. The sheep didn't know they'd lost the race. Probably wouldn't care, either."

In the winter and spring, the Blackgoats do not have to haul water; instead, they use melted snow. During these months, a small stock tank is placed in the corral to catch rain and snow, which become drinking water for the animals. Buckets are left outside the hogan to collect water for cooking purposes. Danny knows having water keeps his family alive and adds, "We always take water every way we can."

CHAPTER SEVEN

NAVAJO FARMING

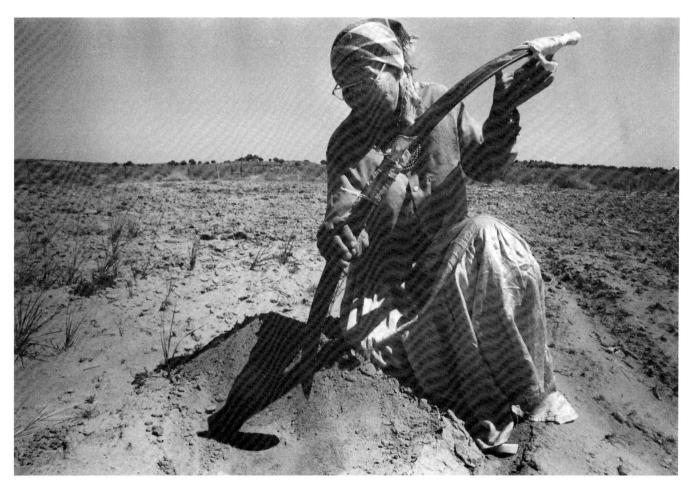

"The rain and snow bring us everything we need to get ready for the planting." - ELLA DEAL

THE CORN GROWS UP.

THE WATERS OF THE DARK CLOUDS DROP, DROP.

THE RAIN COMES DOWN.

THE WATERS FROM THE CORN LEAVES DROP, DROP.

THE RAIN COMES DOWN.

THE WATER FROM THE PLANTS DROP, DROP.

THE CORN GROWS UP.

THE WATER OF THE DARK MISTS DROP, DROP.

-SONG OF THE NAVAJO HOME GOD13

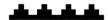

THE DESERT BLOOMS WHENEVER IT RAINS. THEREFORE, to the Navajo, the seed in the ground waits for water to make it grow. The People value water because it is a limited resource, and they have developed certain patterns to help their crops grow. Ella Deal plants seeds in a valley not far from her summer camp. The winter and spring snows melt into the soil and keep it damp. Ella says, "The rain and snow bring us everything we need to get ready for the planting." With some luck, rain in the summer keeps the soil moist. From May until September, the Deals grow squash, melons, beans, and potatoes in their fenced garden, which is an

acre in size. "We have been using our land for about twenty years. This place has been good," Ella says.

Ella glances up at the sky and says, "When you plant, it is best to come before the sun wakes up or you will roast." She tromps through her fields, stopping to examine the small sprouts from earlier plantings that now are breaking through the ground. Ella passes the corn, potato, melon, and squash planting sections, stopping repeatedly to pull weeds surrounding the seedlings.

As she works, she says, "This planting and keeping a garden is hard. There is always work to do. I have always helped with the planting. When I was with my mom and dad, my job was to scrape away the weeds. If you don't care for the vegetables and soil, then they will not be good. I used to help with the watering, too. My job was to water each plant and make sure it would not get thirsty. Our Navajo way is to spend time with our plants. We feed each one. We clean around each one, for these are the gifts of our Mother Earth. We must work together like partners to make it right."

Other farmers use a variety of methods to grow healthy plants. Some dig a six- to eightinch cup around each plant so water will drain directly to the seed. Others cover the seed with damp soil. Because the Southwest soil is so dry and water scarce, these techniques enable the seed to receive more water.

Ella walks to the northeast corner of the field. "This is my bean place. Today my daughter Daisey and I will put bean seeds in the ground." Ella picks up a long metal rod that leans against the fence. "This is a part of our old car. We use it now as our planting stick. The old people used

"Our Navajo way is to

spend time with our

plants. We feed each

one. We clean around

each one, for these are

the gifts of our Mother

Earth. We must work

together like partners

to make it right."

a hard stick called greasewood. I push the stick deep into the earth to make a hole. Now I plant the seeds."

Ella scrapes the weeds aside and pushes her modern planting stick into the soil, making a fiveinch-deep hole. From a jar, she pours fifteen seeds into her hand and drops them in the hole. She announces, "We have to make sure our plants grow. If the soil is

dry, we put in lots of beans, like today, but if the dirt is really, really damp, then it is really nice for the planting." The women take turns, Daisey digging the next hole with the planting rod and Ella placing seeds in the soil. Daisey says, "I have to follow the rule with the planting. I must stay in a straight line. I face one way until I get to the end of the row, and I start the next row from that end. Then I have neat plants."

The women are hot after planting several rows of beans. Ella says, "It's time for a rest, and fry bread, and coffee. The sun always chases us indoors."

During the summer, when the soil becomes

dry, the women carefully water each individual plant. "We mostly rely on the rains," Daisey says. "We're lucky because we live in the high country, and we get more rain than most Navajos, but when the dirt does get dry, then we haul water. We bring barrels of water down in a truck to the field. When it doesn't rain, we use a half-bucketful of water for each plant. We do this every day for a week at a time. We like wet, damp soil. Snow comes in the winter and gets the dirt real wet, but we have to help it along sometimes in the summer. When we do things right, then we have good crops."

In the fall, the Deals have a tremendous task ahead of them, as all the vegetables must be harvested before winter. The last beans are picked, and they begin to gather Indian corn, break squash from the vines, and dig new potatoes.

On a windy day in October,
Ella and Daisey bring in the corn, checking each stalk and pulling off ears of corn. These corn ears appear different from the summer corn—they are larger, with weathered leaves—so Daisey

Douts breaks off an ear and pushes aside the husk.
The various shades of red, yellow, white, and purple kernels are bright surprises. She explains that this type of corn is used to make cornmeal patties. "We call this Indian corn, and we make many recipes with it."

Pale yellow, orange, pink, and green squash still lie on the ground, covered with leaves. Ella, her son Percy, and Daisey must tug and twist each squash until its stem breaks. Finally, Percy piles squash in the outstretched arms of his mother and sister, and they load up the pickup

truck. Some of the squashes are so large that it takes two people to carry them.

The Deals harvest their potatoes last. They walk to Ella's favorite potato-digging spot. She declares, "Fresh cracks in the ground mean the potatoes are ready." Using her shovel, she digs into the soil, breaking the earth, and then triumphantly pulls up several pink potatoes with her hand. "I dig with a shovel and reach down and grab up the food. You can't dig too close to the plant, or you will cut the potatoes under the ground. We always follow the planting line; then we know we'll get all the potatoes."

By late afternoon, small piles of fresh potatoes are scattered across the field. Ella has stopped digging and is sorting potatoes. "I put the potatoes into three piles. The largest potatoes we eat or give to friends, the middlesized ones we give to the dogs, and the smallest we use for seeds next summer. The largest potatoes and the small ones we store in our cellar. We store all our foods in there; then

we can have vegetables to eat all year-round."

Outside her hogan, Ella rests quietly for some time, staring at her garden, but gradually she begins to talk, softly at first. "It is really nice to have a garden. When you don't have one, you get hungry for it. When you buy vegetables, you don't get much, and they don't taste the same." She pauses, her voice becoming stronger. "If we need help with the garden, then all our neighbors will come. We feed them. Everyone helps around here. These old people used to feed everyone and anybody and anyone. That is what my grandmother and grandfather told us to do. You treat them that way, and they treat you that way. Nobody will ever

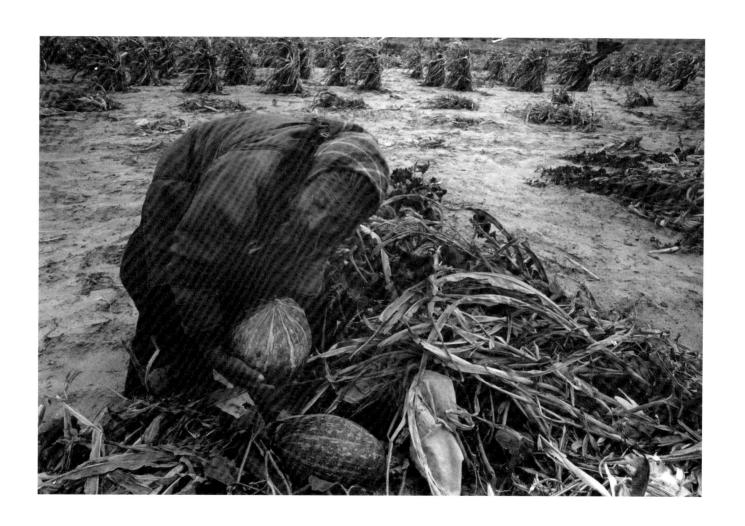

go hungry here. My grandmother told me that they had hard days. Everybody in the area came together and shared everything. Then everybody was okay. When we have a meeting, we bring food. Right now, meat is hard to get, but my family has plenty, so we bring meat to the squaw dances to share with The People. I am going to tell my children and everybody, because we want this way to keep going and going.

"We even give people a place to sleep," Ella continues. "When you are around Navajos, they let you sleep where it is safe and warm. If you get stuck in the mud, someone will help. We take care of everyone. When you get to town, it is different. You have to pay to eat and sleep, even for a cup of coffee. In California, you even have to pay for a glass of water. Here, we share our home, our help, and our food."

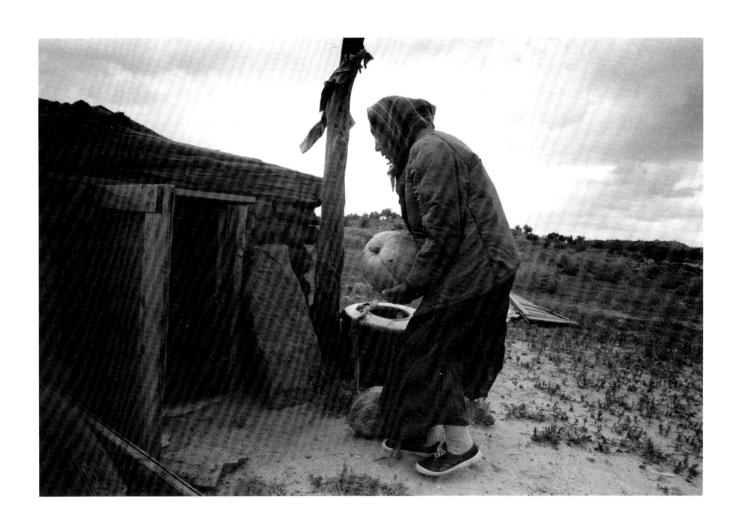

PART

3

WOOD

WOOD IS ROOTED IN MOTHER EARTH, THE WOMB. SHE NOURISHES OUR WOOD AND CARES FOR IT. OUR WOOD AND OUR TREES PROJECT INTO FATHER SKY, AND THEREIN THEY, TOO, ARE NOURISHED AND STRENGTHENED. WOOD PROVIDES SHELTER AND WARMTH. – STEVEN A. DARDEN

JUNIPER AND PIÑON TREES SPRINKLE THE LANDSCAPES OF NAVAJO LAND,

often growing at elevations from 4,500 to 7,000 feet.¹⁴ These are hardy trees. They grow in harsh landscapes and exist with little water, in sweltering heat and freezing cold. The hairy-textured juniper bark is an excellent fire-starter.¹⁵ Below the bark is a smooth, reddish-brown wood that emits a sweet, cedar scent when burned. Piñon bark, with its dark brown and black color, has a flaky texture and delivers a pine fragrance when burned.

Above the piñon-juniper woodland grow ponderosa pine, oak, and aspen above 6,500 feet, mostly in the Chuska Mountains. Aspen and oak give off mild scents when burned, while ponderosa scents the air with pine.

The Navajo harvest wood for hogans, summer shelters, sheds, corrals, fences, and weaving looms. Wood is a vital resource for The People, giving them protection and warmth.

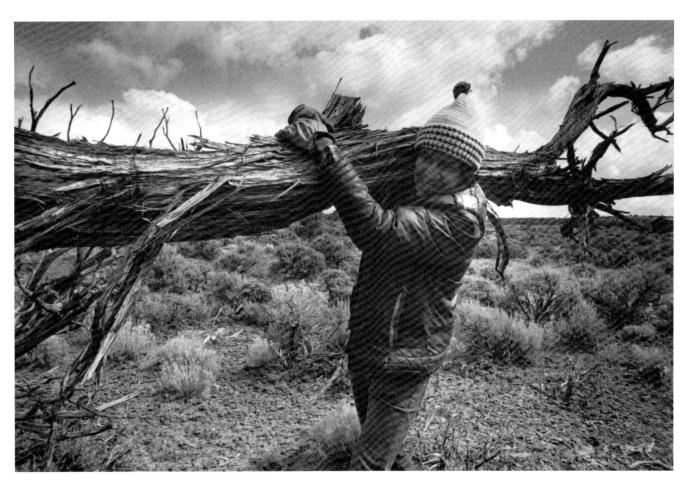

"Tonight, the outside will be cold, but the inside will be warm." - ROBERTA BLACKGOAT

CHAPTER EIGHT

FIREWOOD

IT FEELS LIKE SNOW, AND ROBERTA ASKS HER SON Danny to go to their wood-cutting spot to gather juniper. Juniper and piñon are her main sources of heat. There are several advantages to these types of wood. They give off only small amounts of smoke, so the wood can be burned

inside a hogan, and they are quite hard, so they burn hot for long periods of time.

Danny drives his pickup to a juniper woodland about three miles from his mother's camp.

This juniper area appears to be a graveyard of dead trees and sage. Stark and lifeless echo, juniper skeletons are sprawled throughout the area, like hovering ghosts. All is silent and still except for Danny, who surveys the trees, looking for a well-seasoned juniper.

He selects a large tree and swings his axe, stripping its small branches first and then

cutting into the main trunk. Loud cracks echo, breaking the silence, and bits of juniper fly into the air. When he finishes, a large pile of branches and log chunks are all that remain. One chopped tree fills his entire pickup, but this supply will only last Roberta for a week.

He selects a large tree and swings his axe, stripping its small branches first and then cutting into the main trunk. Loud cracks echo, breaking the silence, and bits of juniper fly into the air. Back at camp, Roberta's skirt swings back and forth as she cuts wide strokes into logs. Nearby, long juniper poles are piled in a curious fashion—like sheaves stacked tepee fashion. Roberta explains, "We put our wood this way so it will dry and become hard. In the winter, we will have the right kind of wood." She stands in silence for a few moments, and then resumes her chopping. When finished, she

and Danny carry in the cut wood, and she helps him unload the truck. Roberta announces, "Tonight the outside will be cold, but the inside will be warm."

CHAPTER NINE

THE CORRAL

One by one, the

sheep and goats

begin to lie down

to rest for the

IN A GREEN VALLEY NOT FAR FROM DINNEBITO, ARIZONA, sits Oskar Whitehair's ranch, consisting of a large, pink stone house and two corrals. Seventy-two-year-old Oskar has a talent for building corrals. "I build my corrals strong and sturdy," he states.

Close to the house is a large corral made of juniper. "I can build these corrals in a day. First, I gather lots of cedar branches and logs. Then I

dig lots of postholes in the ground and make a great big circle. I push the cedar posts into the holes. Then I take the branches and weave them together around the posts."

The pressure of the woven branches keeps the corral upright and tightly attached. Oskar uses neither nails nor wire to connect the branches. "It's kind of like putting a puzzle together. You have to fit the right pieces in the right places." night. When they seem settled and quiet, Oskar bids them goodnight.

After the structure is finished, Oskar hangs old tin cans and dirty shirts on the corral fence. "I put these things up to keep the coyotes away. You see, the wind blows, and the cans make noises that scare them. I hang up the shirts because the coyotes don't like a man's smell. Our odor scares them away real fast."

Walking toward his second corral, Oskar says, "I'll build a new one when the ground in this old corral gets real dirty. I'll pick a spot that's flat and close to a tree. That way, the animals can get shade." The sun is high and hot, but the animals inside this second corral, built around two piñon trees, appear cool. One small lamb squeezes its head through the juniper branches of the corral and bleats loudly. "This one is just saying hi."

In the afternoon, Oskar stands in the open field, ready to round up one of his flocks. "These sheep and goats live in the corral closest to my house." He whistles and yelps at the animals as they move along through the grasses. "These guys have been out getting fat, and it's time for them to come in and go to bed." The animals' hooves stomp the ground. Some walk slower than others, and Oskar becomes impatient

and yells at them in Navajo to get along. As he opens the corral gate, the animals scurry in to drink from the water trough.

One by one, the sheep and goats begin to lie down to rest for the night. When they seem settled and quiet, Oskar bids them goodnight. As he walks back toward his house, he says, "My animals have a pretty good home."

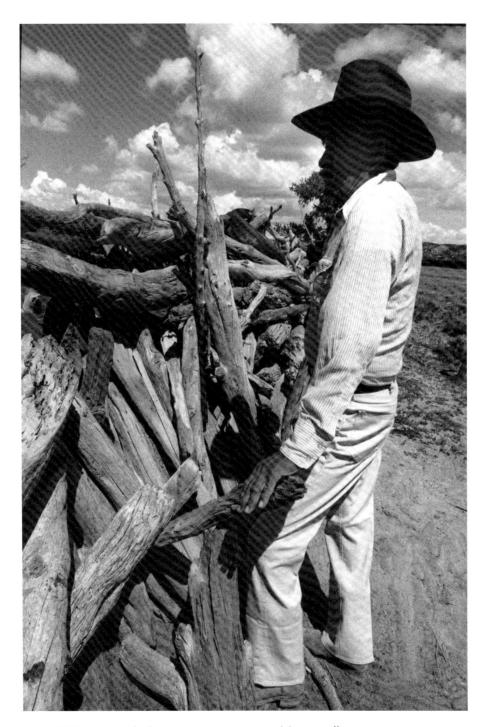

"My animals have a pretty good home." – \mbox{OSKAR} WHITEHAIR

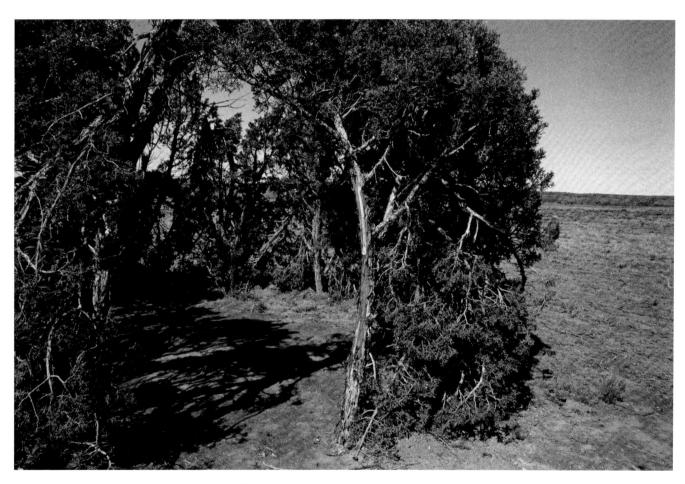

"This shelter keeps us cool and not so sweaty." – YAZZIE

SUMMER SHELTER

summer months, a

Navajo family will

move from its hogan

to its summer shelter,

an open-walled ramada

that gives shade and

that can withstand the winter months, leaving only minor repairs to be made for annual of their summer use. The original structure can easily be constructed in half a day. Juniper or piñon logs and boughs are used to build the shelter, which has four to six posts set in the ground in a rectangular shape. These main posts are it last a connected by stringer posts, and the roof is made of long, thin poles During the warm

the roof is made of long, thin poles that lie flat across the stringers. The boughs cover the roof poles. During the warm summer months, a Navajo family will move from its hogan to its summer shelter, an open-walled ramada that gives shade and allows free flow of the afternoon breezes.

Every spring, Yazzie and his

family, who live close to Dilkon,
Arizona, move from their hogan to
their summer shelter. "May is the
time to start getting ready for the summer," says
Yazzie. "Before I move my family into the shade,
I always check it to make sure it is plenty strong.
We live close to the south reservation border,
and our summers are pretty hot these days. This
shelter keeps us cool and not so sweaty."

allows free flow of the
afternoon breezes.
feet apart.
holes are if
cedar post
where flow of the summer, says
feet apart.
holes are if
cedar post
strong.
The same of the summer, says
foot apart.

Before the family moves to its summer home, Yazzie must rebuild parts of it. "Sometimes our winters are harsh, and we lose roof poles and boughs. Our main posts stay still. They don't go anyplace. They've been in the ground now for about twelve years."

His old summer shelter is covered with brown, dried roof boughs, but the main posts, stripped of their bark, are thick. Yazzie inspects the sturdy structure and says, "We need only new boughs this year. Everything else is okay! When you make a summer home, you have to take your time and get good wood and cedar boughs. Good wood makes it last a long, long time. This summer shelter is old

now and is still doing fine.

"When you build one, you have to go to the forest and cut down the fat cedar posts. For these, I go to Window Rock. I cut six fat posts that have a V shape at the top. I call these the forked-end cedars. Then I cut about twenty skinny, tall posts and lots of cedar boughs. I load the wood and boughs in my pickup and drive them to the summer-shelter place.

"To start, you have to dig holes about two feet deep and about six

feet apart. You make a nice rectangle after the holes are in the ground. Then I set in the fat cedar posts and have them stand tall and sturdy.

"Next, put lots of logs across the stringer poles to make a good roof, and lay them about half a foot apart. To make a good shade, cover the roof poles neatly with cedar branches and leaves. Make sure they lie flat, to make the most shade for the shelter. To make even more shade, we lean some long poles against the roof. We put the poles on the west side and cover the poles with more cedar leaves and branches.

"Sometimes, in the old days, when it would get cold during the early fall, we put cedar branches around the bottom part of the shelter to keep us warm. This summer shelter here is half a modern one because we put plywood around it instead of cedar branches. I'll be taking down this plywood because we want to feel the breezes this summer, and we don't want any vents. Then, when September comes, I'll put the plywood back up."

Yazzie drives to a nearby forested area to gather fresh juniper boughs. With an axe, he cuts several large branches and loads them into his truck. Back at his summer home, he removes dried, brittle boughs from the roof and tosses up the new ones, later arranging them neatly. He says: "Now we're ready for the summer. I'll move in a few beds, a shelf, a chest, some cooking utensils, and of course a lantern. I like living in this kind of home. When I was young, I would lie on my sheepskin at night and look up at the stars through the cedar leaves. It was good to see the moonlight shine through the roof and onto us. In the morning, I'd look up again and see the cedar posts and green leaves. Living in a shelter, it feels good to have the ground below and the cedar and its leaves surrounding me."

PART

4

ANIMALS

ANIMALS ARE AN ANCIENT GIFT FROM THE HOLY PEOPLE—DIYAN DINÉ. WHEN BORN, THE ANIMALS ARE AS INFANTS. WE, THE NAVAJO, CARE FOR THEM THROUGH THE PROCESS OF HERDING. WHEN THEY GROW, THEY PROVIDE FOR US.—STEVEN A. DARDEN

THE SPANISH BROUGHT LIVESTOCK TO THE SOUTHWEST IN THE SIXTEENTH

century. This introduction radically transformed the Diné way of living, from hunters and gatherers to livestock tenders. Food, fiber, and transportation became deeply rooted into the Diné way of being. Horses allowed the Navajo to move easily from camp to camp and herd sheep. Cattle provided food and material for making shoes, clothing, and tools. Goats and sheep supplied food and fiber.¹⁶

"Sheep, goats, horses, and cattle were central to the evolution of the Diné society and economy, but from the beginning, the sheep mattered the most." The animals are revered and considered sacred members of a Navajo family. They keep starvation away and offer security by providing meat for food, wool for clothing, bedding, weaving, and sinews for bows.

Navajo women are always thinking about their animals. Sheep must be protected at night from coyotes and guarded so as not to wander off. During lambing season, the women must be certain lambs suckle and are kept warm. Except for the hide and wool, every part of the sheep is eaten. Herds of sheep act as a safeguard, and sheep-herding families know they will always have food. Roberta Blackgoat shared, "My kids always tell me that when they are away at boarding school, they miss mutton and are always hungry for it."

Even though it can be tough to eat, goat meat is as popular as mutton among Navajo people. The goat hair, which is known as mohair, is used in weaving. Although it is awkward to spin, the hair delivers fine yarn for rugs.¹⁹

Navajo legends attribute the gift of weaving to Spider Woman, a holy person, who taught them the artistry. The Navajo-Churro sheep has had a profound effect on weaving practices. Its wool is preferred for weaving rugs, blankets, saddle blankets, and clothing. The fiber's inner coat is fine to medium, and its outer coat is medium to coarse. The amount of lanolin in the fibers is minimal, so the wool can be easily spun and does not require much washing. Some weavers use the inner wool directly from the sheep and exclude the steps of washing and carding. In the late 1800s, Navajo rugs became a major source of income. Coming from Spider Woman and passed down from generation to generation, rug weaving is an art that supports the economy.²⁰

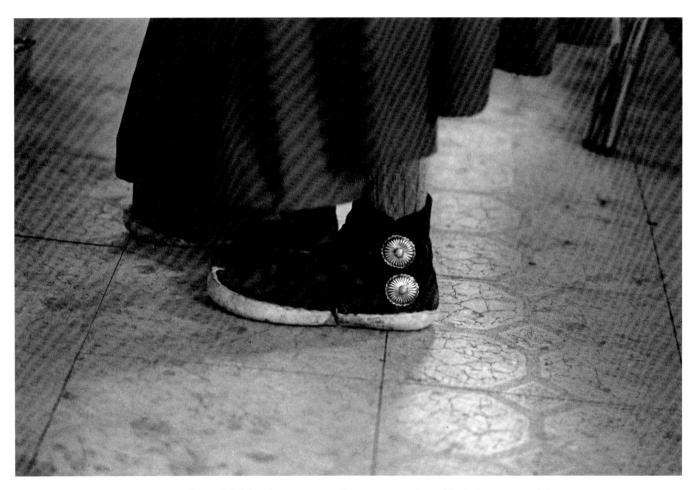

"His uncle told him how to make moccasins. He's been making them since he was a boy." – STELLA WORKER

CHAPTER ELEVEN

MOCCASINS

"We spend our

SAM WORKER IS A WELL-KNOWN MOCCASIN MAKER IN the Leupp, Arizona, area. His uncle taught him the craft when he was a small boy, and now, at the age of sixty, Sam spends his days cutting and sewing cowhide to supply moccasins for his family and the community.

Sam and Stella are quiet as they sit working in their hogan: Stella at her loom, brushing down yarn and weaving; Sam on his mat, surrounded by tools, cowhide, and buckskin. He is now ready to sew a gift for his wife—a pair of moccasins.

Silently, Sam spreads a piece days like this. of six- by twelve-inch cowhide on the floor and, using a sharp knife, I weave and Sam cuts the outline of the sole. While sews. There are he works, Stella explains how Sam just two of us now. readies the hide: "Go out to the Our children are field and find a cow. Let its hide lie all grown up." in the sun. It needs to dry. Sam cuts the good part of the hide to make it soft, then buries the hide strip in the sand. The sand is wet. This makes it soft. It stays in the sand for about two days. When he takes it out

Sam's hands shake as he pulls the hide tightly to stretch it. He molds the hide onto a concave board. There, he hammers it, rounding the sole into the shape of a foot. When the hide needs to be softened, he dips it in a bowl of water. Sam uses buckskin, purchased from the trading post, for the upper part of the moccasin. As he puts

of the sand, he scrapes off the cow fur. Now it is

ready to make a shoe."

the long section of precut skin on top of Stella's foot and around her ankle, the skin forms the shape of a shoe. Satisfied that the buckskin piece is the correct size, Sam joins the two skins to form the moccasins.

He begins to sew. Using the awl, he punches two holes in the cowhide and one hole in the buckskin. With his fingers instead of a needle, he laces the buckskin upper to the cowhide sole. While he punches and stitches, his hands work in a rhythm, using the pulled-down-stitch

method. He tugs and pulls each stitch separately to tighten it. Making a pair of moccasins takes about three hours; Sam works quickly and precisely.

"We love our land," Stella exclaims. "There's no place just like this here. All my kids were born here except for one. My husband was born on this land, and so was his mother. I was a sheepherder. Sam was a sheepherder, too, and he

worked for the railroad but then hurt his back very, very bad. Because he hurt himself, he cannot work for the railroad or be a sheepherder. Now he makes moccasins all day long. His uncle told him how to make moccasins. He's been making them since he was a boy."

In Sam's youth, he used a natural thread made of sinew, which is a tendon from a deer, goat, or sheep. He would stretch and moisten the tendons and twist the fibers together to form a thin thread. Over the years, Sam has changed material and now uses fishing line to sew the skins together.

When Sam finishes sewing the buckskin to the cowhide, he pushes a long stick inside the shoe and presses it against the seams. With a hammer, he taps the seams against the stick, rounding and blending each buckskin seam. The hands rub, shape, and mold the moccasin so it will fit Stella's foot; he then removes the moccasin, rinses it in water, and wraps it in a wet towel. Stella says, "It's easy to sew and shape the hide when it's wet. When it's dry, you can't do anything."

Sam continues working on the second moccasin. He uses the same procedure—punching holes, threading hide, and tugging the fish line. He does not rest or stretch until he has finished.

Stella sits close by, working at her loom. "We spend our days like this. I weave and Sam sews. There are just two of us now. Our children are all grown up. Sometimes they come to visit, and sometimes our grandchildren come to visit. We have a big family. Some of my children live

on the reservation and some off. We are happy when they come back to our land." The land is obviously synonymous with home.

When Sam finishes sewing both shoes, Stella slips on the moccasins. Sam measures the place for three buttonholes and cuts the leather. Next, he fastens the buttons. At last, her moccasins are ready to be worn.

"When the moccasins are new, you have to wear them right away to have them take shape," Stella says. "You keep them on until it gets dark, way into the evening. You can put oil on them to keep them soft. When you wear them all the time, you get used to it, and you know your feet will be warm. When I was a little girl, I didn't wear shoes, just moccasins. Later, when I got a pair of white men's shoes, my friends called my feet big dippers. They would say, 'Hey, where did you get those big dippers?' Now I only wear moccasins. They feel good."

CHAPTER TWELVE

BRANDING

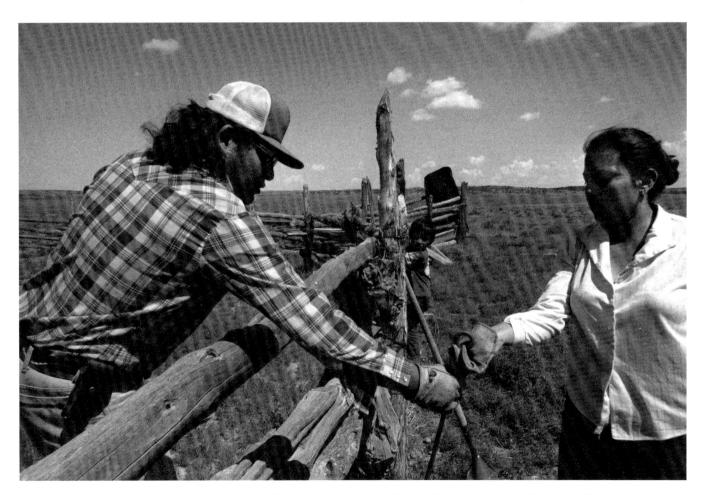

"These cows are easy to have. They're good, and they know how to behave." – ELLA DEAL

IN THE DISTANCE FROM ELLA AND LEONARD DEAL'S CAMP, 100 head of steers, heifers, and calves graze around a nearby water hole. The Deal's cattle require little care. Leonard tends the herd weekly "by counting the cows and looking them over to make sure they are okay." Ella says, "These cows are easy to have. They're good, and they know how to behave. They don't run off very much." Most of the year, the animals eat reservation grasses, but when snows are heavy, Leonard must feed them hay. During the winter and spring, the calves are born; in the summer, the Deals have to brand them.

Branding, a cooperative effort for the entire Deal family, involves more planning and organization than any other task. The grown children return to help. Ella says, "Branding our cows is hard. There are many jobs to do. Everyone helps. If you come to watch, we make you work. No one sits."

The event takes place in a special corral that is used only for branding. Ella's family built the corral when she was a small child. The corral's hard juniper branches have been tightly woven together in a circle 100 feet in diameter. Through the years, various parts of the structure have been rebuilt, but, sixty years later, this corral is still used by Ella and her family.

On branding day, all family members are awake by sunrise. After breakfast, Ella's grandchildren take the horses to the corral to await the action. At the camp, Ella and her daughters, Daisey and LaVern, and her daughter-in-law, Christine, make hominy stew, which will simmer all day over a fire to be ready

after the branding. The women fill a large ice chest with soft drinks and ice water and load it into Ella's pickup. Leonard, his son-in-law Tom, and his son Percy load ropes, branding irons, and juniper wood into Leonard's truck. The family climbs into the two pickups and drives to the corral.

They move quickly to get ready for the branding. The women unload the trucks as the men build a fire. Soon the flames roar, and the heat is strong—a hot fire is needed to heat the branding irons. As the fire burns to red coals,

Percy and Leonard ride to a nearby mesa to round up the herd and push the slow-moving cattle toward the corral. Once inside, the cows begin to move in a circle. Thick dust rises as the animals continue their pacing. Although only the calves are to be branded, the men bring all the cattle into the corral. Christine says, "The branding is just for the babies, but

we have to bring everyone in so the babies will come in, too."

When the cattle are inside the corral, Christine places several different brands in the red coals. The heifer brand is **OO**, the steer brand is **ST**, and a third brand worn by both steers and heifers is -**N**, the Navajo tribal symbol. Next, she quickly covers dirt across a section of each rod to keep heat from traveling up the handle. After a few minutes, the branding irons change from black to red.

While the branding irons heat, the men select a large male calf from the moving herd. Tom twirls a lasso in the air and throws it over the calf's neck, then quickly braces the rope around

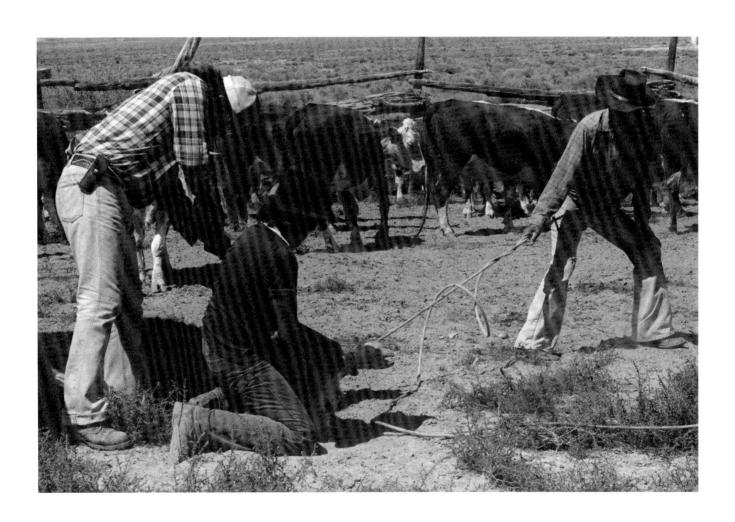

his own body and moves toward the branding post. This post, usually located in the center of the corral, is used to secure the rope and calf. With the help of other men, Tom pulls the rope and wraps it around the post as the calf struggles to get free. He then lassos the calf's hind legs. As the men push the bawling calf down on its side, Percy calls for the branding iron. Christine passes it over the fence to Ella, who hands the hot iron to Percy. Leonard and Tom hold the rope while

Percy sears the animal's rump. Smoke rises from its singed fur and hide as the calf bawls and his eyes bulge. Percy tags the young male's ear and then ties a length of rubber tubing around the testicles to neuter the calf.

The branded calf looks rather stunned. As the men loosen the ropes, the animal jumps and stumbles back to the herd in search of his mother. Christine comments, "Some cows cry and yell, and some are quiet. Some act like they don't even care."

Next, Leonard selects a second

male calf. The men rope, wrestle,
brand, tag, and neuter the husky
animals. "We brand the big babies
first," Ella says. "Some cows have
babies in the winter and some in the spring.
We brand the largest ones first because they are
strong, and they have more energy. When we
start, we have more energy, too! Then we finish
with the smaller ones."

At one point during the branding, Ella makes a count and notices a few cows missing. She asks Daisey and LaVern to round up the remaining animals, so the young women leave their job of recording the number of heifers and steers branded. They ride east on horseback toward the cornfields. An hour later, they return with ten nervous cows. When the animals reach the corral gate, they refuse to enter. The men push all the cattle back outside of the corral to mingle with the strays. A minute later, the men herd all the cows back inside. Christine explains, "Some of the cows don't want to go into the corral. Even though they are not getting branded, they remember when they did. But cows like company,

so if all the cows are coming into the corral, even the stubborn ones will feel safe enough to follow."

During the day, the family repeats the branding process forty-five times. The air is hot and dusty, and the cows continually pace inside the corral. Except for a few breaks, the Deals work constantly.

By midafternoon, the branding is finished. After checking to see that all the calves have brands, Ella opens the gate, and the men push the cattle back into the fields. While Christine puts out the fire, everyone else helps load gear into the trucks. The grandchildren ride the horses back to camp as the trucks follow.

Back at the camp to rest and eat, Ella is glad to find her hominy stew still simmering on the woodburning stove inside her hogan. She exclaims, "After a hard day, it is good that we don't have to come back here and cook. The food is already ready." The family relaxes under the shade tree near the hogan, eating stew and yeast rolls and chatting about the day's events. The cows and their newly branded calves graze in the nearby fields. The branding is over for another year.

"Some of the cows don't want to go into the corral. Even though they are not getting branded, they remember when they did. But cows like company, so if all the cows are coming into the corral, even the stubborn ones will feel safe enough to follow."

CHAPTER THIRTEEN

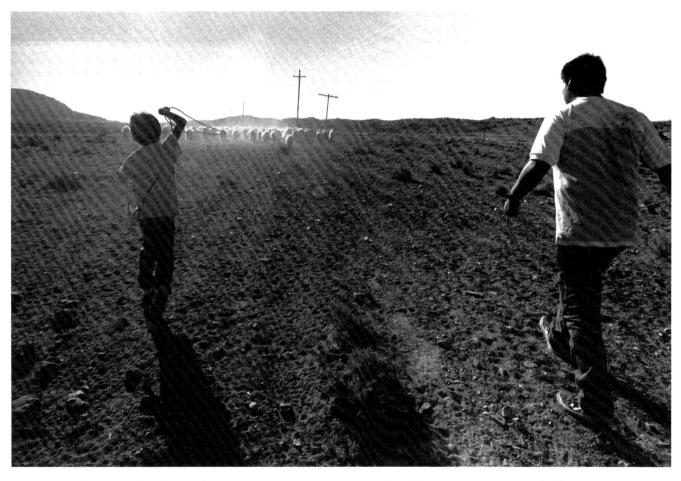

"When we herd, we listen to the animals and do what they want to do." – ELLA DEAL

ELLA AND LEONARD DEAL ARE SHEEPHERDERS.

Thirty years ago, Ella's father gave them a flock of ten sheep and two goats as a wedding gift. Today, their herd numbers 150 sheep and goats, an important source of income for the family. Surplus animals are either sold at auctions or butchered, and their wool is sold or used for weaving.

Ella and her daughter Daisey stand outside the Deals' hogan this morning and watch Leonard in the distance as he herds their flock of animals back to camp. The white coats of the sheep and goats contrast sharply with the green fields. Ella says, "The sheep and goats got up early this morning, and they have been grazing, just eating grass and drinking water." Leonard moves the animals back toward the corral as Ella continues, "He knows when it's time to bring them back because they are missing home, and it's getting too hot for them." During warm weather, sheep and goats graze in the early morning and evening when it's cool, but in spring, fall, and winter, the animals graze from midmorning to noon and from afternoon to sunset.

As Leonard swings a lasso and yells to the animals to move on, a sheepdog leads the parade through sage and rabbit brush. Three other dogs harass the herd, snapping at their heels. While the dogs bark loudly, the animals bleat in complaint and stomp their feet in rebellion. Heads bobbing in objection, the animals kick up clouds of dust as they enter the corral.

Once inside, the babies nestle close to their mothers to nurse. Leonard checks the flock, crooning to them. After feeding their lambs and kids, the sheep and goats cluster together in the shade of the corral walls. All is quiet. Leonard

closes the gate and says goodbye softly, returning to his hogan for a cup of coffee and rest. It is time to return to the peaceful part of the sheepherder's life.

All the elder Deals herd sheep and spend many hours with the animals. "Sometimes, it can be a boring job," Daisey says. "When my mom is with the sheep, she brings her wool and spins and cards it. I bring a book, and my dad does leather work. We can fill the time and get two jobs done at once. Even though we're busy, we still keep an eye on the sheep."

The Deal family's life revolves around their sheep to prevent overgrazing damage to the land. The family moves with the flock to a different camp every season. "We move from camp to camp and move the sheep, too. They go where we go because

then we can find them lots of food," After feeding Daisey says. "We used to move all four their lambs and seasons, but now we don't have to. We only have three hogans because kids, the sheep the hogan at our fall camp is too old and goats cluster and broken down. We're not worried, together in the though. We know our sheep get enough shade of the grass from three moves." Each camp is a corral walls. home, complete with hogan, shed, and corral. The winter camp is in a forested All is quiet. area of their land, but the spring and

summer camps are on flatter terrain. "In the winter, we take our sheep to the mountain. They eat trees and leaves up high because the ground is covered with snow. In the summer, they eat in the flat areas."

The sheep eat rabbit brush, greasewood, piñon, and juniper. Ella says, "My sheep eat many kinds of grasses. We chase them to the salty weeds up on the mountain. If you don't chase them up there, they will eat dirt! We're lucky to have enough for the sheep to eat, but we do worry about finding enough water for them. When we herd, we listen to the animals and do what they want to do. Sometimes

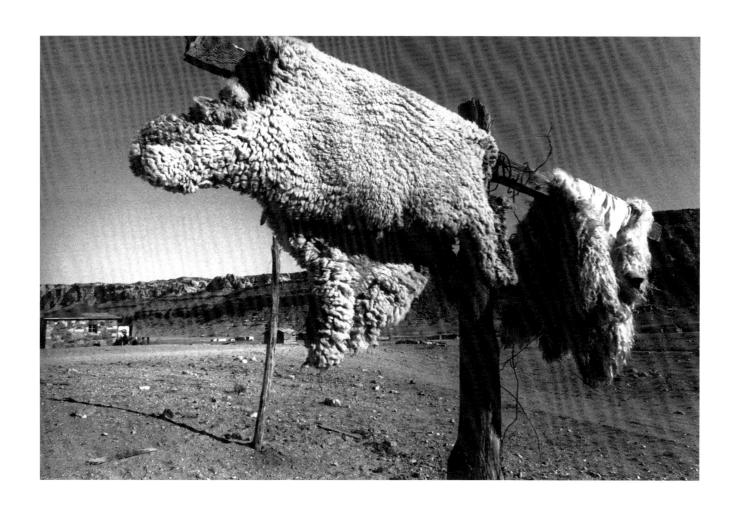

they want to drink and drink, and in the winter, they eat snow for water. We can't always count on water in the summer. The hole dried out last summer, and we had no water. The tribe had to haul water to us."

Aside from worrying about the scarcity of water, the Deals must protect their sheep from wild animals. "It's best to stay with your sheep. If we just let them run around, then the coyotes get them. So far, we've lost two lambs this summer. The coyotes don't kill just one sheep. They kill one and then keep on trying to kill them all. You have to watch for foxes, too. Most of the time, the sheep don't run off. We chase them across the wash, and then they eat their way home."

In addition to watching the herd daily, the Deals have seasonal tasks to perform, such as tending the ewes at lambing and shearing in the spring. "We [three women] shear before it gets hot. It took us twenty-five days to shear our sheep. We're busy," Ella says. Also in

the summer, the family dips their sheep with a chemical solution that controls pests and skin diseases. "The tribe has a place near our area where we can go and dip our sheep. We usually dip after the Fourth of July. Some of our sheep might carry a bug, so we give them a shot and put them through the dip."

Family members including Aside from children and elders help with worrying about the herding, lambing, shearing, and dipping. Learning to care for the scarcity of livestock is considered an important water, the Deals maturing process for Navajo kids. must protect their The Deals' sheep and goats are sheep from wild both a source of livelihood and a animals. "It's best source of pride. With a smile, Ella says, "When you're able to care for to stay with yourself and your sheep, you are your sheep." grown. It's hard to keep sheep, but

we like them. We're proud that we have them. My children get hungry for mutton. They come home and butcher. They get homesick for it, and we're glad we have our sheep and goats."

CHAPTER FOURTEEN

COOKING A GOAT

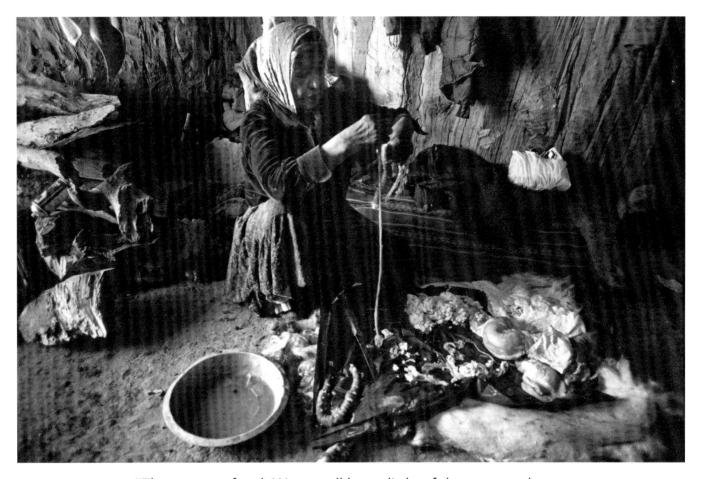

"They are my food. We use all but a little of the goat or sheep. When we don't eat the meat, we miss it. We don't have to go to the store and buy it. It is all right here for us." - ROBERTA BLACKGOAT

SHEEP AND GOATS ARE VITAL TO NAVAJO PEOPLE WHO live on the reservation, as sixty percent of their diet consists of products from these animals. Sixty-two-year-old Roberta Blackgoat recognizes the vital importance of her goats and sheep. "They are my food. We use all but a little of the goat or sheep. When we don't eat the meat, we miss it. We don't have to go to the store and buy it. It is all right here for us."

Today, Roberta says she is hungry for ribs, liver, and blood cakes, which she makes from her sheep or goats. She examines the animals in her corral with a knowing eye until she finds a fat goat to butcher. Tying a rope around its neck, she drags it close to her hogan. The animal begins to object as it is forced to the ground. Roberta steadies its shoulder with her foot as the goat bleats in protest. With a knife, she slits its throat—one quick slash. Then she explains, "This is living, is my way of living, and it is a part of being close to the earth."

After the slaughter, Roberta pulls the carcass onto a plastic garbage bag and puts a bowl under the goat's slit neck to collect the blood. With a knife, she cuts open the chest and lower body, removing the intestines, stomach, pancreas, liver, and heart. She also cuts out the ribs, transferring these body parts onto a second plastic sheet, for these are ingredients she will use today.

Roberta drags the plastic, loaded with goat parts, into her hogan. Her son Danny carefully carries the bright red blood in a white bowl. Roberta says, "It's time to start cooking." She builds a small juniper fire, adding sticks to the flames "so the fire will make a good bed of coals." Her stove is an oil drum cut in half, with a metal

pipe attached to the flat top that runs up to an opening in the ceiling. While the fire burns down, she cuts the goat ribs into four sections. Once the task is complete, Roberta drops the ribs onto a grill that sits in front of her stove. They sizzle as they hit the grill, and soon the air is heavy with the smell of juniper and cooking meat.

As the ribs cook, Roberta holds up both the small and large intestines and says, "I'll make sausage links with these." She checks the ribs, and then takes the intestines outside, where she pushes the partially digested grass out of each strip and then rinses the string in cold water. When she returns, she takes

With a knife, she

slits its throat—one

quick slash.

Then she explains,

"This is my way of

living, and it is a

part of being close

to the earth."

the two intestine strips and wraps them around her finger as a starter link. When the link is formed, she removes her finger, twists the long intestines, and continues the curling and wrapping motion. "You have to do a good job and make it neat." The intestine is wrapped in a foot-long coil and then placed on the grill next to the ribs. She repeats the process until all the intestines have been used.

Roberta pays attention to detail in her cooking. The ribs are all cut the same width, and the goat links are wrapped tightly, one link on top of the other. The ribs and links are evenly arranged in a straight line across the grill.

As the ribs and links roast, Roberta turns to her next task. "When I cook a goat, I have to be quick and do two or three jobs at a time. I have to make sure I get to cook as much as I can so as not to waste anything." She pauses. "So, I'll start to make the blood cakes. This is good food."

Roberta separates the lining of one of the goat's four stomachs from its muscle layers. She carefully lifts the bowl full of goat blood and pours it into the lining. The sack bulges, but not a drop spills.

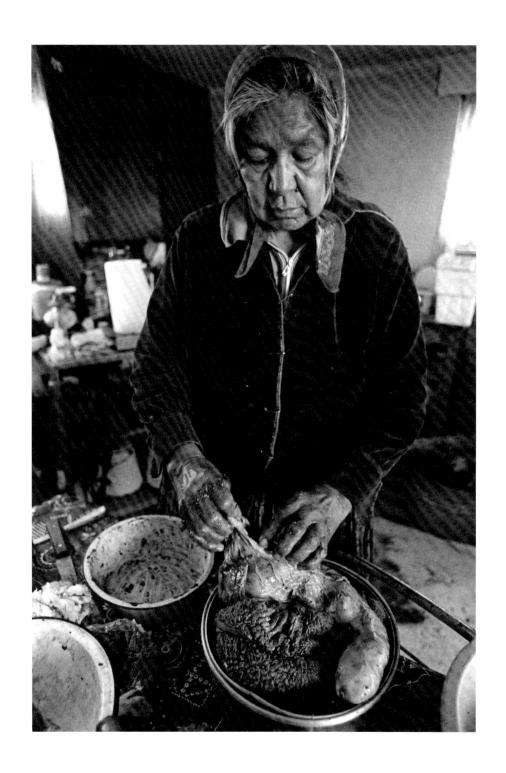

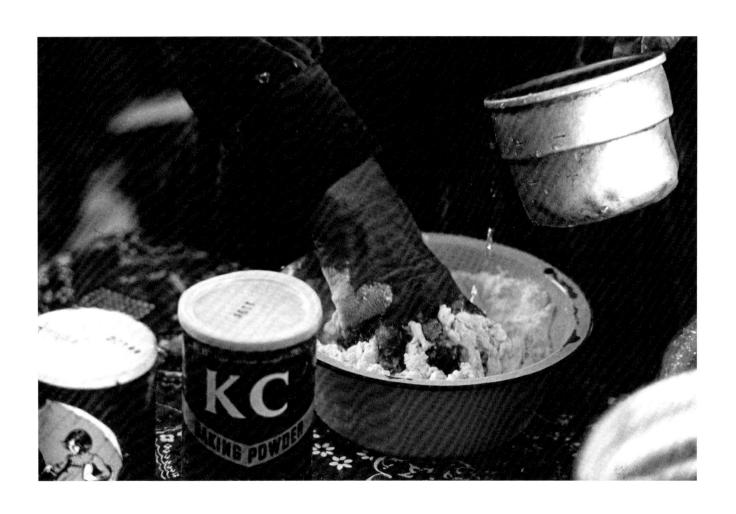

Roberta calmly places the full sack back in the bowl, making sure the opening is closed and folded over.

When the ribs and links are grilled, Roberta takes a break from cooking. She and Danny have a late brunch, eating meat right off the grill. She mentions, "both the ribs and the links taste greasy and sweet." Too soon, the grill is empty.

It is now time to move on to Roberta's rock house. Roberta and Danny carry the goat carcass and the bowl with the sack of blood to her kitchen, which is slightly larger and has more cooking utensils and a stove with an oven. Roberta says she feels more comfortable here. She spends most of her time in this two-room rock structure, where one room has four beds and the other is a large family kitchen.

Once Roberta is settled, she prepares the next recipe, a liver dish. She begins by pinching and squeezing a second goat stomach until it becomes soft and juicy. When the stomach is just right, can dig a pit outside, she walks outside to empty the juice. build a fire in the pit, As it pours out, some spills onto her hands. Roberta's eyes grow large, and she hurries back inside, grabbing a wet towel to wipe off the hydrochloric acid, a harsh digestive juice. "The wet inside the stomach sure hurts my hands, so I get it off really, really fast."

When the stomach is clean, Roberta makes stuffing for the inside. First, she tears the goat liver, fat, and leftover intestines into small bits. As she works, she tells stories concerning different parts of the goat. She holds up the rumen, similar to the gizzard, and says, "Men don't eat this. If they do, they are the first to get lost in a war or the first to get shot." As she shows the sternum and goat

nipples, she explains, "If teenagers eat these, then they will have bumps on their faces—I mean, pimples." Roberta takes the bile ducts off the liver. "If you eat this, you will go blind."

She picks up the shredded liver and fat and squeezes them together. "I add a little bit of salt," she says as she measures it into her palm. Then, using her hands, she stuffs the mixture into the soft stomach. Roberta works quickly, and every movement is exact. Soon the bag bulges, and

she ties a cheesecloth strip around the stomach opening. The stuffed The stuffed stomach stomach sausage resembles a large sausage resembles gray cheese. "Now you can cook it a large gray cheese. lots of different ways. You can roast "Now you can cook it on a grill in your hogan, you can it lots of different boil it in water, or you can dig a pit outside, build a fire in the pit, and ways. You can roast let it bake." Today, she chooses to it on a grill in your boil it on her woodburning stove. hogan, you can boil it in water, or you

and let it bake."

Roberta puts a few inches of water with the stuffed stomach in a large pot and stokes the stove with juniper wood. The fire heats quickly and warms the room. After the water boils, she turns the stuffed stomach several times so it

will cook thoroughly. The room smells of freshly cooked meat. She hardly pauses for a breath before starting the next recipe.

Roberta repeats, "We use almost all of the sheep and goats," emphasizing just how essential these animals are to the Navajo. She adds, "We even take the fat after it melts and put it in the can [an old Crisco can]. I use it as shortening for fry bread. We take the goat head, boil it, and eat the meat; it tastes good, and we are healthy."

While the liver sausage boils, Roberta takes

the heart and pancreas outside and puts these parts on a rack to dry in the sun and fresh air. "These foods hang on a wood rack, which is up very high so animals such as coyotes, dogs, and bobcats cannot get them."

Roberta turns the organs every few hours so the sun will dry them thoroughly. If the air is dry, the process takes one full day, but it may take as long as two or three days if the air is damp. She brings the organs indoors during the night.

It is now time to make Navajo blood cakes. Roberta explains, "Now, I have been saving the best for last." She unties the stomach lining and pours the blood into a bowl. Next, she peels three potatoes, slices them crisply into thin pieces, and dumps them into the bowl. She tears off sections of goat fat, drops them into the mixture, and adds three large handfuls of cornmeal. Roberta stirs the mixture with her hands and watches as the cornmeal thickens the liquid, then explains, "I add a small handful of pepper, a sprinkle of onion salt, a handful of salt, a little bit of chili powder, and a few chopped chili peppers." Her hands continue to stir the mixture slowly.

The fire in Roberta's cookstove burns low, so she adds more wood and warms a heavy castiron skillet. Next, she rubs the skillet with goat fat, pours in the mixture, and puts the skillet in her oven to bake. Soon the delicious aroma of potatoes, meat juices, and seasonings fill the air. Thirty-five minutes later, Roberta removes the baked blood cake from the oven. The watery, red batter emerges as a solid, dark brown cake.

As melted goat fat sputters around the sides, she places the hot skillet to cool on a pile of dry firewood stacked near the stove. Moments later, she slices the cake into long, thick wedges. The taste is bland, wholesome, and heavy.

Roberta traditionally makes fry bread to accompany the goat feast. She makes the dough with her hands. "Oh, I don't cook exact. I cook by feeling, and I put lots in my fry bread. I put

four handfuls of bread flour in a bowl with a little bit of baking powder, a little bit of salt, and some warm water—just a little at a time—then I mix it together with my hands. I might use a little more water and a little more flour to get it right."

While lard boils, she makes balls of dough and shapes them into large, flat pancakes. She then slaps the dough back and forth, stretching it around her hand into a paper-thin pancake, which she drops flat into the hot grease. The dough quickly bubbles and starts to rise. Three minutes pass before Roberta turns it over. After the bread cooks to a golden brown,

she removes it from the skillet. She fries the remaining dough in the same manner, and when she is finished, six crisp rounds of fry bread cool in a bowl. "I like to top the bread with salt or honey."

Roberta has just spent the entire day cooking a goat. She shares some of it with Danny and her neighbors. This was a day of hard work, and now it is time to relax and enjoy the feast.

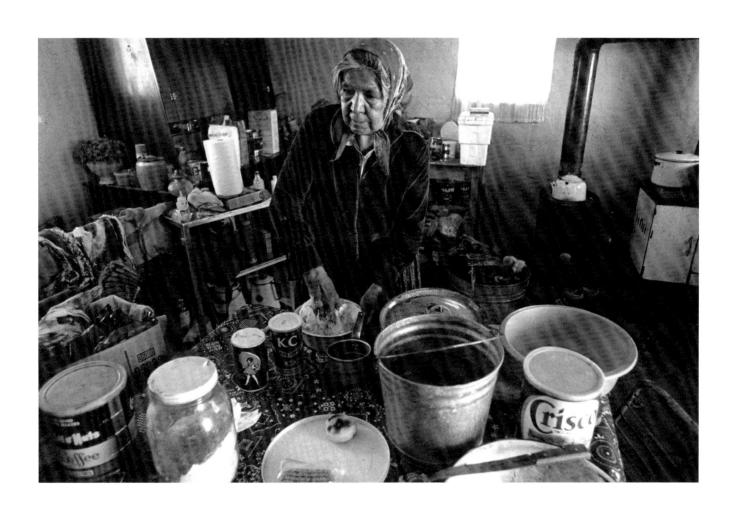

CHAPTER FIFTEEN

HORSE HOBBLE

SALLY GORDY TRAVELS TO HER PARENTS' CAMP NEAR Black Mesa, Arizona, where her father is well-known for his leather work; in particular, horse hobbles. The horses are kept in a corral during the night but are free to roam during the day. Joe Gordy is proud of his five horses. "They are good animals. I don't have to watch them all the time. I can kind of trust them, except for one. He is on the wild side, and so he gets a horse hobble to keep him under control."

A horse hobble is a strip of leather that fits securely around the horse's forelegs. Once the horse is put in the hobble, it is able to step with its back legs but can only hop with its front pair. Joe says, "I can tie the strip around the horse's legs to keep him gentle. Then he can't run far."

Joe stretches a one- by eighteen-

inch cowhide strip tightly across
a nearby log. "This hide has been
buried in the damp ground to make
it soft. It is easier to work with now."

Holding a sharp knife with his fingertips, he
scrapes the hair off the hide. As Joe removes
the hair, he says, "Way back in the old days, we
used to scrape the hide with a stone to get rid
of the hair. I learned this [way] from my uncle."

After the final scrapes, the hide is clean, and its
texture is rough.

Tanning, the Navajo way, is a lengthy process. Joe explains, "It takes lots of work.

After I scrape off the fur, then I tan the hide. I

cure it and work it over. I hit it against the trees. You always keep it moving." Joe demonstrates this technique and stretches the hide under his foot. He repeats, "I always keep it moving to make it get soft. If I don't, it becomes hard. At night, I do let it sleep. It is wrapped in a wet rag to keep the air and the dry out." He continues to work the hide and then hands it to his wife, Alberta. "I need a rest," he laughs. Alberta folds and twists the strip, then slaps it

against a woodpile. The hide is never motionless in her hands.

While Alberta works the strip, Joe takes out some cooking oil and pours it into his palms. When Alberta hands him the hide, he lavishly applies it to the leather. "I rub cooking oil on the hide. The old people used animal brains, or you can use bone marrow. This oil makes the strip easier to twist and shape."

Joe buries the cowhide again in the soil. The moisture must slowly

penetrate the skin to make it pliable. "You want to get the wetness into it, but you don't want it to go very fast. You want the soil damp but not too full of water. This cowhide will stay in the ground for one to two days." Joe cautions, "If the hide doesn't feel right when you take it out, then you have to bury it again and tan it until it gets right." Taking a shovel, Joe scoops out a few mounds of damp soil, places the leather in the ground, and covers it thoroughly.

"I don't have to watch them [horses] all the time. I can kind of trust them, except for one. He is on the wild side." - JOE GORDY

As Joe sips coffee, he continues to explain the making of a horse hobble. "We will leave that strip buried in the wet soil for a few days, then dig it up, pull it out, and shake it clean. It is now ready to become a hobble. However, today I'll show you with this rawhide."

Joe takes a strip of leather from his bag. "First, I tie a knot at one end of the strip. Then I cut a half-inch slit at the other end. Close to the center of the strip, I will fold over part of it to make a loop. Now the loop is the size of a horse's leg. You want the loop slightly bigger than the horse's leg, so you must allow it to give a little.

"Then I hold the loop together with my fingers and let the rest of it hang below my hand. I put the loop over a log and twist the hanging strips

together real tight, making a five-inch middle strap. You have enough strip left over after the twisting to make a second loop.

"This second loop has the knot and slit, so I hook the two together. That's it. Our horse will use a hobble like this for a long time. When I make the buried leather into a hobble, it will dry in the sun and be ready for my wild horse. I'll have to be tough with my horse when I put my horse hobble on him. At least, he won't go far now.

"I like to make horse hobbles. They are really from the old days and the old ways. My uncle taught me to take my time, work slowly, and do it right. He told me that to really work the leather, you need to keep it moving. My uncle taught me a lot about leather. I'm glad he did."

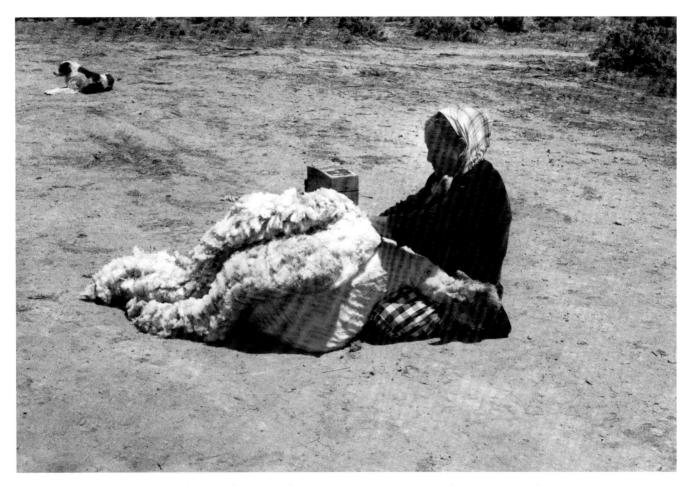

"We always shear in the spring. You cannot shear too early, or the sheep will get cold." – HAZEL K. NEZ

CHAPTER SIXTEEN

NAVAJO RUG

Hazel's grandson

holds the sheep's

head in one hand,

strokes the animal's

A FINE-QUALITY NAVAJO RUG INCLUDES BOTH A TIGHT weave and an intricate design. Hazel Nez, a weaver from the Big Mountain area of Arizona, is well-known for her beautifully crafted rugs. Hazel lives alone in a big, mesa-top camp that consists of a hogan, corral, weaving shed, and two houses. Above the door of one of the houses is a wooden sign: Hazel K. Nez.

Hazel is extremely knowledgeable, having been a weaver for more than forty years. She explains that her mother taught her how to weave. "She stood over me and watched until

I did it right." She continues, "It takes me about two months to make a rug, but of course it depends on the size. I take all the things from around me to make a rug. I love to weave. I love to spend time with the weaving."

There are many time-consuming steps to prepare the wool before the actual weaving may begin. Hazel quietly in Navajo explains, "We always shear in the spring. You can't shear too early, or the sheep will get cold." Hazel and her grandson Sonny, who is six, hike toward their sheep grazing in the field nearby. As Sonny Hazel la runs around the flock, he whistles, yelps, and skips, and the animals slowly begin to move toward the camp.

Hazel's eyes scan the flock, looking for an old male to shear first. She throws a lasso around the sheep's head and says, "I've done pretty good on my first try." After pulling the frightened animal away from the herd, she ties his legs together and gently pushes him over on his side.

Hazel's grandson holds the sheep's head in one hand, strokes the animal's nose with his fingers, and speaks quietly in Navajo to calm him. Hazel announces, "When I was a young child, my job was just like my grandson's. I had to hold the sheep's head to keep him quiet so that my mother could shear."

Hazel takes her long metal shears and begins cutting wool in the sheep's chest area. Over and

over, the shears clip, cutting sections of the animal's fleece free. After the wool is removed from the chest, she snips the wool from the shoulders and hind legs. Shearing the fleece with one hand, she holds the solid wool piece in the other. With one side finished, Hazel and her grandson flip the sheep over.

When the second side is shorn, Hazel gives the sheep a pat on the

back and unties his legs. The sheep jumps up, shakes, and trots off to the herd, baa-ing loudly. Hazel laughs and says, "Oh, he is calling his friends and telling them that he is clean and nice and cool." She wraps the wool into a bundle and stuffs it into a bag. "Now, let's go back to my house and clean it."

Inside, Hazel begins the washing of the wool. She shakes the fleece vigorously, spreads it on the floor, and picks out small burrs and sticks.

At last, she speaks. "The sheep can pick up lots of stuff while they are grazing. This coat is very dirty, so it needs to be cleaned with soap and water." After dumping a bucket of water into the washtub, she throws the fleece into the tub and lets the wool soak. She empties the dirty water and repeats this cold-rinse process four times. Next, Hazel washes the fleece, adding warm water from the kettle on the stove. This time, she uses detergent, rinses the fleece, and hangs it out on a nearby fence. After a few hours, the warm Arizona sun has dried the fleece, and it is ready for carding.

Carding is the process of straightening the wool fibers before they are spun. Hazel uses two wooden tow cards, flat paddles of plywood made with wooden handles and metal teeth, to comb the fleece. She sits on a goatskin close to her house and takes up her tow cards and a small piece of wool. She places the wool in the metal teeth of one card and with the other card begins to comb the fibers. Back and forth, Hazel transfers the wool from one card to another, brushing the fibers until they are straight. As she cards, she says, "It takes me about two weeks to card enough wool for

a rug. If you card slow, you never get tired. You must always have to think that you are going to card or spin or weave more. There is always a job to do." She continues carding until the wool comes off the cards in fluffy strips called batts. "Pretty soon, I'll have a nice big pile of soft wool ready to spin."

Throughout the next two weeks, Hazel cards all her wool into a soft, fluffy pile. Finally, she declares, "The wool is ready for spinning."

Spinning transforms the carded batts into yarn; the spindle is the tool used for this task. Hazel brings out her drop-spindle and a bag full of batts. As she sits on the front step in the sun, where her dogs and cats rest close by, she twirls the spindle once and attaches a yard of yarn to demonstrate how easily and smoothly it goes around. She then picks up a wool batt and attaches it to the tip of the spindle, spinning the stick with one hand and tugging the fibers from the batt with the other. The batt changes quickly into a thick, airy piece of yarn. She twists this fat yarn around the spindle, making the yarn tighter. Hazel continues to pull the yarn off the

She pours water into

a large kettle and

heats it on the stove.

When the water is

hot, she puts it into a

metal bowl, and she

adds some cold water

to make it lukewarm.

"If you wash the wool

in really hot water,

it shrinks. The wool

won't be any good."

spindle with a downward motion, until it attains a fine texture.

All is quiet except for the humming of the spindle. Hazel's hands appear to be dancing. She extends her feet in front of her, with heels to the ground and toes in the air, wrapping the spun yarn around them. She continues the spinning for several hours, then stops for the day. When she stands up, Hazel says, "I'll spin again tomorrow and maybe the next day. The spinning for one rug will take a couple of weeks. Like I said before, when you weave, you always have a job to do."

After the wool is spun, it must be washed a second time. "You just can't get it too clean," Hazel says. She pours water into a large kettle and heats it on the stove. When the water is hot, she puts it into a metal bowl, and she adds some cold water to make it lukewarm. "If you wash the wool in really hot water, it shrinks. The wool won't be any good. If it shrinks, it gets coarse." She adds detergent to the water and soaks the yarn. It blends with the soapsuds as Hazel swishes, rubs, and squeezes it.

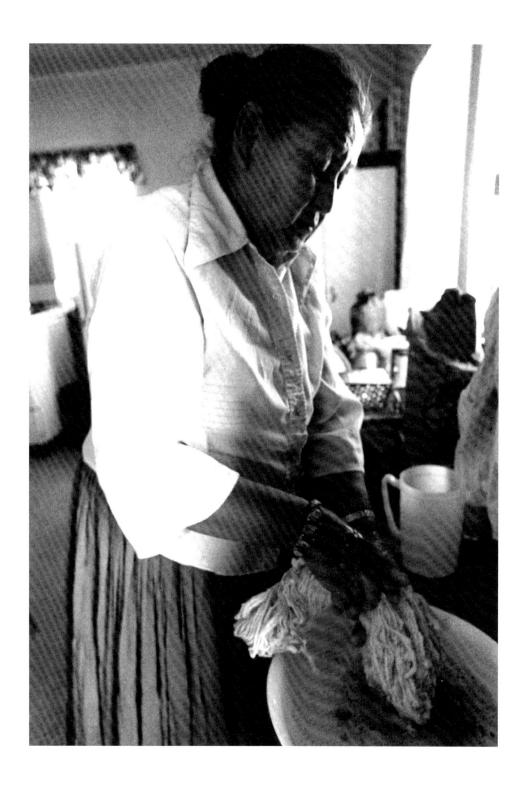

"We used to use yucca to wash the wool. Today, I use Tide. In the old, old days, my grandma used yarn as big as her fingers because she never washed it to make it clean. It would be fat from the dirt."

Hazel rinses the wool thoroughly after

several washings. The last rinse water appears clear. "My water is clear and see-through because the wool is clean," she says proudly. When she wrings the yarn with both hands, clean water falls to the floor. "Now I'll hang it up to dry." Hazel takes the skeins of yarn outside and walks toward her juniper-post fence. "This is my drying fence. I'm going to wrap the wet wool around the fence posts so the wool will dry." She attaches the yarn to one fence post and walks back and forth, wrapping the yarn from that fence post to the next. A slight breeze moves the yarn as it dries on the fence.

After wrapping the wool, Hazel says, "Next, I check for lumps and then take them off the wool." Her fingertips run along the wool, removing the small bumps. "I wrap the yarn, so it stretches and becomes all the same size. If you don't stretch the yarn, then it comes out fat and thin. It can brown. I really change sizes on you, and that doesn't I take it comake for weaving a good rug." soaks for

Hazel begins the long task of unwinding the dry, clean yarn after removing the knots from the wool. Back and forth she walks, looping the yarn around her hand and arm. As she removes the skein from her elbow and loops it over to form a neat bundle, she says, "Like I told you before and I'll tell you again, there is lots to do when you weave."

Hazel's wool has been sheared, washed, carded, spun, and washed a second time. The next step is to dye it. She uses several different methods to obtain her variety of colors. She may create natural wool tones from blending the light and dark aniline (commercial) dyes, or she often uses plant dyes made from bark, roots, and fruit. Occasionally, Hazel might use store-bought dye, but she explains, "I like to dye using the things from the land. Sometimes we spend a day gathering plants to use for the dyes. I take my grandkids, and we have a picnic. You can make lots of different colors from the plants and

As she sits on the

front step in the

sun, where her

dogs and cats

rest close by, she

twirls the spindle

things." Hazel takes great delight in this aspect of the weaving process.

She plans to use shades of white, gray, black, red, and brown in her next rug. "The white and black are easy. They just come from black and white sheep. For brown, I use wild walnuts. The red dye I buy from the store." She has traveled to Oak Creek Canyon, Arizona, more than two hundred miles from her home, to collect the walnuts. "I let those nuts soak overnight, and then I boil them in the morning, maybe for two hours. The water turns dark, dark

brown. I add the wet yarn and boil it some more. I take it off the heat and let it soak and cool. It soaks for a few days. Then I take it out of the pot and rinse it until I know the dye is stuck into the yarn. I let it dry and then wind it up into a ball. It is ready for the weaving."

Hazel enters the weaving shed and stands by her loom. "This is it! This is where I do my work, my weaving work." The large piñon-pine posts of the loom are notched together to form a rectangle, with the heavy lower posts acting as a base.

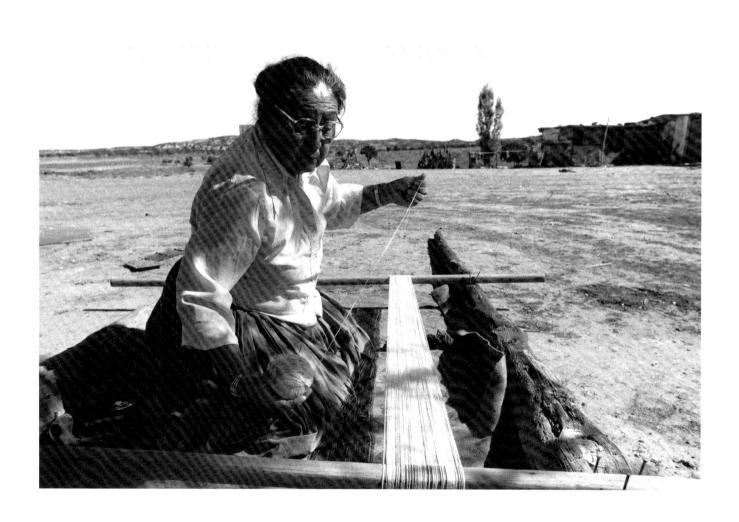

As she prepares the loom, Hazel explains, "The first thing I do is string the warp threads onto the warp frame." The warp threads are the foundation of the rug, and the warp frame is a separate piece of the loom, complete with two posts and two crosspieces.

She measures the warp frame with a tape

Back and forth.

Hazel wraps the yarn.

Over and under, she

moves the threads

in a smooth rhythm.

This figure-eight

motion creates two

measure to ensure that the crosspieces are even before taking the warp thread and wrapping it from one crosspiece to the other in a figure-eight pattern. Back and forth, Hazel wraps the yarn. Over and under, she moves the threads in a smooth rhythm. This figure-eight motion creates two sheds, which are two sets of warp threads separated by the alternating pattern. She passes a piece of string through the sheds as a marker and laces the warp to wooden dowels, anchoring it firmly to the loom. This figure-eight motion creates two sheds, which are two sets of warp threads separated by the alternating pattern. She passes a piece of string through the sheds as a marker and laces the warp to wooden dowels, anchoring it firmly to the loom.

Hazel now sits down to weave.

She picks up the cross-yarn, called sheds, which are two the weft, and feeds it through the sets of warp threads warp sheds. In and out, she weaves separated by the the yarn and packs it down with a alternating pattern. weaving comb. Her fingers work quickly. "I like to build the yarn and make rugs. My old man, who died a few years ago, made this comb for me. It is ironwood, and is very hard." Hazel resumes her motion, and all is quiet except for the snap of the warp threads and the thumping of the comb against the yarn. After a few hours, she has woven several inches of the black border of the rug. "Now it is starting to look like something," she says.

She spends most of her daylight hours weaving, and by the end of three weeks, the rug is nearly finished. With only three more inches to go, it hangs on the loom. Her storm pattern is intricate. Its blacks, grays, and browns contrast beautifully with the reds and whites. Like most Navajo weavers, Hazel keeps the designs in her mind, weaving the inner patterns according to her own expectations.

Hazel is anxious to finish the storm pattern rug, so she asks a neighbor to help. She explains, "The end is the hardest part. The strings are so tight." The neighbor wraps the yarn loosely around a thin stick and passes it through the warp strings. Hazel pulls the yarn through a small section of threads with her fingers. She remarks, "My sticks

are all slicky. The lanolin from the wool makes them that way. I used all different sizes of sticks to feed the yarn. The smallest are for the ends." Soon the warp strings are so tight that she can no longer fit the sticks into the sheds. "It's time to use my needle," she states. She now uses a table fork, instead of a comb, to press the yarn down. "The forks are smaller and help me push down the wool very, very hard. My aunt taught me about the fork. It works well when the amount to weave gets small."

The hours pass, the neighbor leaves, and Hazel continues to work at the loom. As evening approaches, the weaving shed grows cold. She stops only to light the lantern and build a fire. A soft glow fills the room, and all is quiet except for the crackling of the fire. Although it seems that there is not a bit of space left to weave, Hazel adds additional yarn to the rug. She says, "You know, you sew it up until the threads don't show. You can't cheat and leave a hole." Over and over, Hazel continues to squeeze the yarn through the minute space. She starts to laugh. "I sometimes don't eat anything all day long. I just sit and

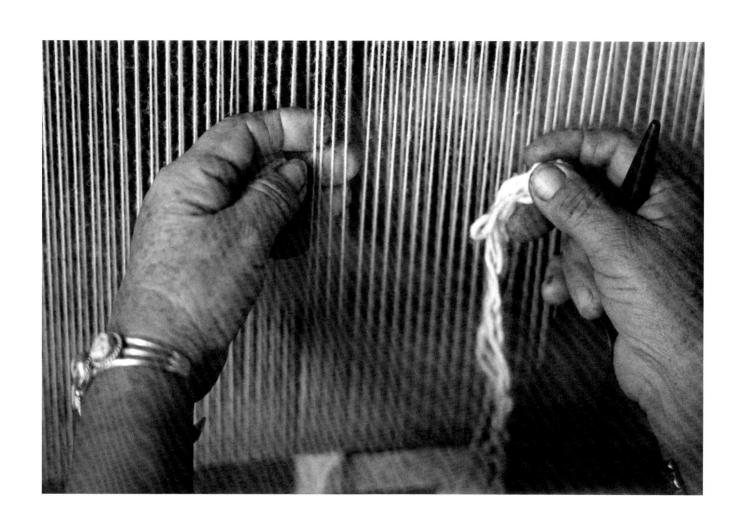

weave. I put my hands on magic automatic!" At last, all the spaces are filled, and with a broad smile, Hazel says, "It is done. The dance with my hands is over." She sits back to admire her rug.

Hazel stands up, stretches, and removes the rug from the loom. Using a knife, she cuts the strings from the warp beams and with short tugs pulls them out. Next, she goes outside and shakes the rug, in the moonlight, to remove any dust.

Inside the house, Hazel lays the rug across her bed, takes out a wire brush, and runs it quickly over the finished work. This brisk movement makes the surface of the yarn smooth. After a few minutes, she stops and holds up her creation. Hazel's voice and posture show signs of weariness, but she is proud of a job well done. "I'm worn out! I'm glad this is done," she sighs. "It's time for bed."

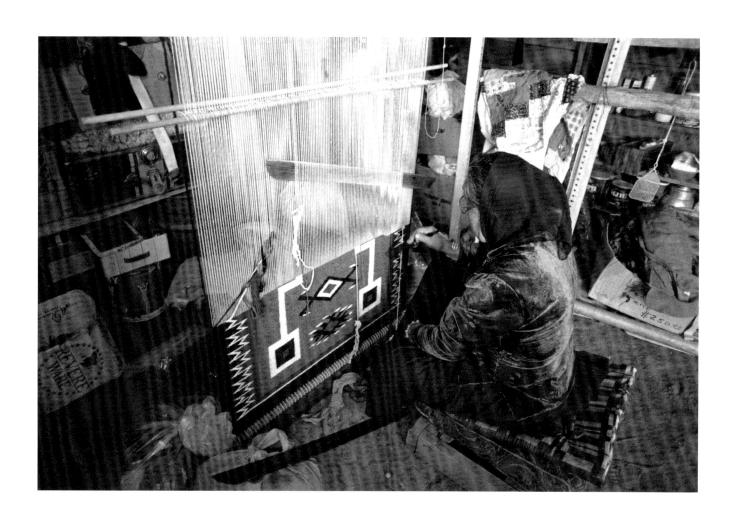

PART

5

SOIL

SOIL IS FROM OUR EARTH MOTHER. SHE IS OUR WOMB, AND SHE NOURISHES US AND ENCIRCLES US WITH HER WARMTH. - STEVEN A. DARDEN

TRADITIONAL NAVAJO PEOPLE BELIEVE THE LAND THEY LIVE ON CANNOT

belong to them. "Instead, a person belongs to the land on which he or she was born. Navajos believe that if they stray too far from that land, they lose themselves and their sense of purpose and direction." ²¹ When soil is turned into mud, it is a valuable resource in many aspects of Navajo life. Mud ovens allow for baking, clay pottery provides containers, and mud roofs and walls in hogans contribute to shelter.

Traditional Navajo shelters, known as the male and the female hogan, exist on the reservation today. The female hogan, which is the most common, is a six- or eight-sided log structure with a rounded mud roof. Its door faces east to greet the morning sun, and only a small amount of fuel is needed to heat the interior. Large families can squeeze ten or more members inside for sleeping. They use sheepskins for bedding. The female hogan is used as living quarters and for ceremonies.²²

Only a few male hogans, known as the ancient "forked-poles hogan," exist today. Located mostly in the western part of the reservation, these conical-shaped structures are used for ceremonies. Navajo builders plaster mud to its sides and add a vestibule entrance facing east.²³

Materials used to construct a hogan are mostly wood and mud. "Heated mud" is used to cover the roof and patch the holes and cracks in the woodpost walls. The mud acts as a sealant, so rain and melted snow can be kept out. "Roof logs are gradually built toward the center, forming a crib-work roof shaped like a beehive with a central opening left for a smoke hole." A leaky roof can be a challenge. Covering the entire roof with mud is a lengthy process. Where wood is scarce, some build hogans with mud and rocks.

Many Navajo people construct several hogans in their camps. The hogan has a meaning that is more than just a place to sleep, converse, and eat. To the Diné, a hogan is a gift from the Holy People.²⁵ A specific protocol occurs when entering a hogan. Once people come inside, they must move in a clockwise direction around a fire which is in the center of the shelter. As they encircle the fire, it is believed that the gift of thought and the ability to organize are instilled within them.

.

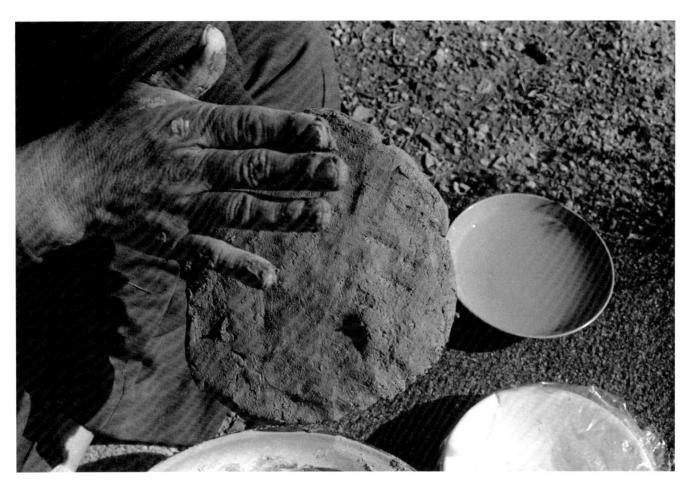

"This will be a beautiful pottery when it is finished." – MARY JOE YAZZIE

CHAPTER SEVENTEEN

POTTERY

The sticky pitch,

another essential

ingredient for

making pottery, is

used as a sealing

glaze. The piñon

needles shine in the

bright sunlight.

MARY JOE YAZZIE AND HER MOTHER-IN-LAW, ANNETTE, are well-known potters from Cow Springs, Arizona. "We have been making pots since we were really small. Our grandmas, aunts, mothers, and everyone taught us," explains Annette. The women call their pottery earth pots because all the materials used—clay, sap, and cinders—come from Annette's land.

On this warm and breezy day, Annette drives to the clay pits not far from her hogan. Annette states, "I have been coming to this pit for clay since I was young." On this site consisting of rocks, sand, and clay, with a few sprawling juniper trees, the women take their shovels and jab them into the earth; their blades clang against rock. The monotonous rhythm of their work takes over, but soon the women create a gray landslide,

breaking loose large chunks of clay. After the dust settles, they pace through the mounds and pick out several good pieces. Mary Joe tosses a few clumps into her bucket and says, "We look for only the best."

"You don't want any sand in your clay," Annette adds. "Sometimes I bang two clay stones together to shake out the sand. The clay must be hard like a rock."

The women dig, pick, and choose carefully until their buckets are full. "This is hard work. I am all sweaty," says Mary Joe. "After we get back to camp, we will soak the clay overnight

in a bucket of water to make it soft and easy to handle."

Next, she treks by foot to a nearby forested area to collect pitch from the piñon trees. The sticky pitch, another essential ingredient for making pottery, is used as a sealing glaze. The piñon needles shine in the bright sunlight. Mary Joe points to brown, sticky pitch oozing from joints of the piñon branches. She picks up a stick

in one hand, scrapes pitch from the bark of a tree, and plops it into a coffee can. She is pleased to find so much. "You see how sticky it is. It's like chewing gum. When we would herd sheep and were hungry, we would chew it like spearmint." As Mary Joe gathers more pitch, she says, "If you don't have enough, then your pot won't get shiny, so let's make sure the can is full."

Mary Joe moves from tree to tree, examining the branches. She says, "You know, when I was little, we used to take a picnic lunch when we went to find gum for making potteries. We used the gum for lots of other things, too. We put it on sores. We mixed it with Vaseline so the sores would heal. Also, you can put it on your face for sunburn or windburn. These old people don't run to the hospital. It's too far. They just use the gum."

After scraping the pitch from one last tree, Mary Joe is delighted. "I am lucky. Some days I walk and walk and find nothing. This is a good day." The next morning at Annette's house, Mary Joe finds cinder stones and firewood. After picking up a handful of the red lava cinders, Mary Joe smiles as she spreads them across a metate and says, "I call these stones ash, and I'm going to grind them until they are very, very fine. Then I'll add them to the clay to help the pot become strong, stiff, and stand up right." She moves the grinding stones back and forth across the lava cinders on the metate. They make a loud scraping sound, but in a short time, she has turned the cinders into a fine red powder. "After

Using the *béézó*, Mary Joe sweeps the ground ash from the metate onto a section of screen. "This acts as my sieve," she says. As she gently shakes the screen, powdered ash falls through into a bucket. "You have to make sure there is no wood, sand, or hair in the ground ash. It has to be pure. If that stuff gets in there, then the pot will go wrong. You want everything to be clean. Now we knead the clay."

Mary Joe brings the bucket from the hogan. She lifts the mass of soaking clay from the water, dumps out the excess liquid, and returns the clay to the bucket. Its wet, shiny surface bears no resemblance to the dusty gray rock she dumped into the water on the previous day. She continues with the next step.

"After you grind the ash stones really fine, you mix it with clay. You make a good dough. The ash must be fine. If it is not, then the clay won't get smooth. You'll have lumps and bumps in the pots. Now, I'll mix the ash and clay until I have the good dough." The gallon of gray clay is soft and easy to mold. From the bucket, she takes a handful of clay, squeezes it, and adds a

little of the lava ash. Again, she reaches into the clay bucket for another handful. Gradually, she increases the mass, kneading all clay and powder cinders until they are completely mixed.

The mixture is now ready to form and shape. Mary Joe says, "Making the pot is the easy part to do." First, she takes two large handfuls of clay. "You kind of make this bottom piece into a piecrust so you are ready to shape the rest of the pot on it. You begin by taking another pottery that is already made, and you put it in the center

of the clay piecrust." She places an old pot on the new base, which is about half an inch thick. With both hands, Mary Joe presses the dough around the pot, using slow, careful fingertip movements to smooth the clay. She takes more clay and rolls it into a long rope. "I make these snake coils and wrap them around the top of the clay base. You keep making more and more strings, and you keep wrapping them around until you have built the side of a high pot. Then you smooth it around a little

bit. You remove the old pot from inside the new pot, and you smooth it more and more." With damp hands, Mary Joe rubs out the ridge coils.

Annette hands her a smooth old corncob, which she uses to pack the clay. "When you are working with the corncob, you can even put designs on the pots. You can add more clay and blend it or make grooves in it. The corncob is a good tool to use in making pots." She swishes the cob around the pot, both inside and out, until the clay is compressed to half its original thickness. Mary Joe pauses and admires her new creation. The base is full and round, and its top is tall and straight. "This will be a beautiful pottery when it is finished."

bumps in the pots."

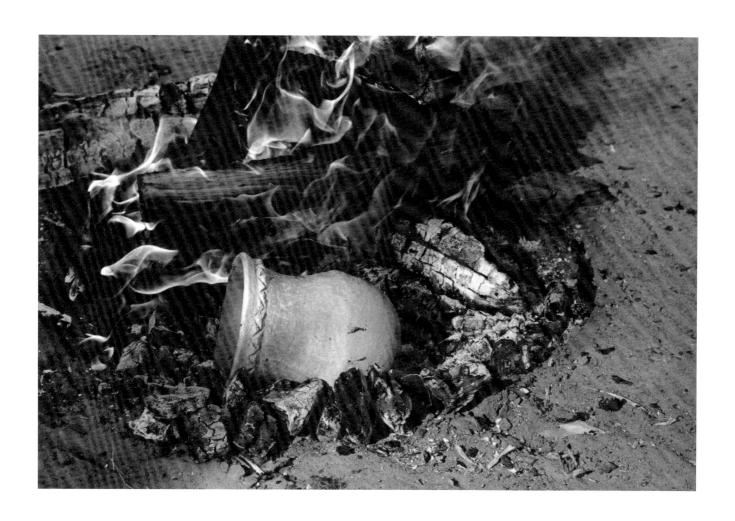

The next step in making pottery is the drying process. "You have to let the pot dry completely. That is very, very important. If you are in a hurry, you can let it dry by the stove for about eight hours. If the clay is thick on the pot, then it will take a few days. If the pots are not dried thoroughly, then they won't cook right. The first time I made a pot, it didn't dry. I just couldn't wait. I was so excited. I wanted to see it cooked. I didn't let it dry enough. I cooked it, and it

cracked and popped! We are not in a hurry, so we will let this pot dry for a few days. Then we know we are safe." Mary Joe enters Annette's hogan, looks for a protected place, and chooses a spot on the highest shelf. She says, "I'll put this pot up really high, so the babies won't get to it and knock it down and break it."

Five days pass. It's time to check for dryness, and so Mary Joe's fingers slide over the clay surface. "It's ready," she judges. "It's good and dry. Now we can fire it." Mary Joe tells Annette and Gail, Annette's married daughter, to begin building a fire. Gail swings her axe, chopping juniper into small bits. With this

kindling and a few large logs, she builds a hot, crackling fire. Mary Joe carefully places the pot on the ground a few inches from the flames. "I'm going to heat it slowly." She leans the pot on its side for fifteen minutes before turning it with a stick. The fire soon burns down to smoldering coals, and the pot is ready to be cooked. Mary Joe uses two sticks to turn the pot, so its mouth faces the flames; she spreads the coals and works them around it. Quickly, she adds more kindling to the fire, covering the coals and pot.

"See," she says as the blaze swirls around the wood, "I can't even tell that a pot is in the fire."

Mary Joe turns to Gail and tells her, "It is time to melt the pitch." Gail places the can of pitch close to the fire as Mary Joe explains, "I put the gum here by the heat because it needs to melt." Before long, the pitch liquefies and begins to boil.

The piñon pitch melts and the pot fires. Different kinds of wood affect the color of the pottery. "Juniper can give you a tan or gray color,

and the piñon wood can give you a white color. The oak makes the pot a dark brown. Sometimes I just don't know. It can always be a surprise. Also, I can change the wood in the middle of the cooking and get different colors."

The fire burns down, so Mary Joe takes a stick and slowly works the pot away from the ashes. Next, she rubs the ashes off her pot with a paper bag. Using two sticks, she lifts the pot and places it on a board. While it cools, Mary Joe checks the boiling pitch. "It is just right. Now we are ready to put the pitch on the pottery."

As she scoops up pitch with a stick and dabs it lightly on the pot, it begins to sizzle and smoke. "Oops!" she says. "The pot is just a little too hot. It is not ready for the gum. You want to let it cool just the right amount of time because if I put the gum on too soon, the heat of the pot will burn the sap black. If you wait a few minutes, then the pot will cool a little, and I can put the gum on. Then it will show the color made from the kind of wood you choose. Any pot can be black. I want to work for a different color."

"We Navajos use our pottery. I can boil water in these pots.
In the old days, this is all we used." - MARY JOE YAZZIE

She tests the pot once more and says, "Okay. We are ready." With a glob of pitch at the end of her stick, Mary Joe quickly rubs it all over the pot, inside and out. The dry, hot clay absorbs the pitch quickly and begins to turn a rich, dark red. She picks up more gum with her stick and rubs down the inside, gently stirring the pot as fragrant smoke rises in the air.

When it has cooled, she rubs the pottery with a piece of waxed paper. "In the old days,

we used piñon boughs to shine our pots." She polishes the pot, and the glaze shines brightly.

Mary Joe is proud of her pot as she holds it up to the sun. "We Navajos use our pottery. I can boil water in these pots. In the old days, this is all we used." With a smile on her face, Mary Joe adds, "I love to be with things in the traditional way. When I was little, and we did things in the old way, I would watch and watch—and remember."

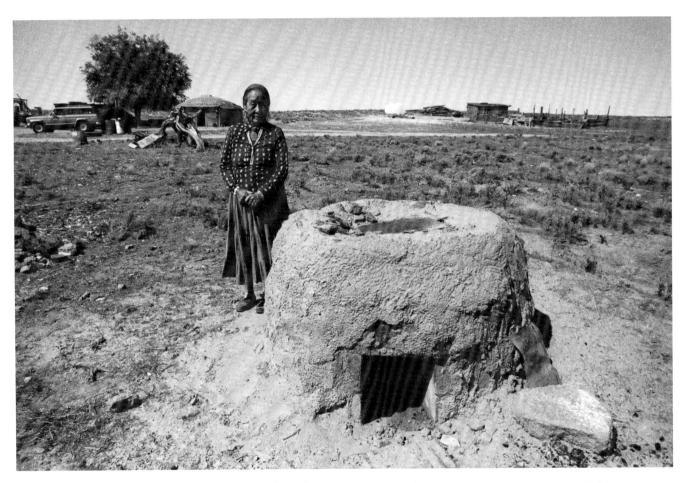

"I make some pretty good food in my oven. These meats come out juicy, and the corns and bread are soft and moist." - ADDIE YAZZIE

CHAPTER EIGHTEEN

MUD OVEN

"My oven comes

straight from the

IN DILKON, ARIZONA, ADDIE YAZZIE, WHO SPEAKS ONLY NAVAJO, uses her outdoor mud oven to cook corn, bread, and meat. Her son Yazzie translates for her. "I make some pretty good food in my oven. These meats come out juicy, and the corns and bread are soft and moist.

"My oven comes straight from the earth." Water, soil, and rock are used to build it. If built correctly, one can last as long as twenty years.

"My husband made my oven for me a long time ago. When he made such an oven, he had to do a good job and take his time."

earth. Water, soil, Addie continues, "First, I pick a and rock are used spot on the ground and make it nice. to build it. If built Pick out the weeds and rocks. Rub correctly, one can water over the place so it is flat and smooth. Then, find lots of big rocks. last as long as These rocks are a special kind. They twenty years." can take lots of hot heat. I call them 'the rocks that don't explode in fire.' After I collect about fifteen or twenty big rocks, put them in a circle, a circle about three feet around, and make sure I leave an opening for a door that faces east because all our door openings face that way. Pile the rocks really tall until you have a nice wall about three feet high. Next, I lay a big flat rock across the top of the walls. That's the roof of

the oven. We find another flat rock for the door. This oven sort of has the shape of a baby hogan."

After the walls are standing, mud plaster is applied to the rocks. "We mix water and lots of dirt together to make the covering for the oven. We call this Navajo cement. With a flat shovel, we scoop up the mud and throw it on the rocks. We cover all the rocks, including the door, with the cement. The mud is about two or three

> inches thick. We let the mud dry, so it is hard, and next we rub it down with water to make it smooth. By then, I have a pretty good oven, and it is all ready to go," translates Yazzie.

Addie's oven is twenty yards from her hogan. The beehive-shaped mud dome blends well with the landscape, making it difficult to locate amid the dust piles and brown autumn fields.

"Sometimes after it rains, some of the mud washes off, so we have to make up more plaster to cover the holes. It's easy to do, and it keeps the oven in pretty good working order."

With a smile, Addie adds, "This oven is a good thing to have. We can bake good foods. They taste good cooked on cedar and piñon coals. I kind of feel like I cook in the earth."

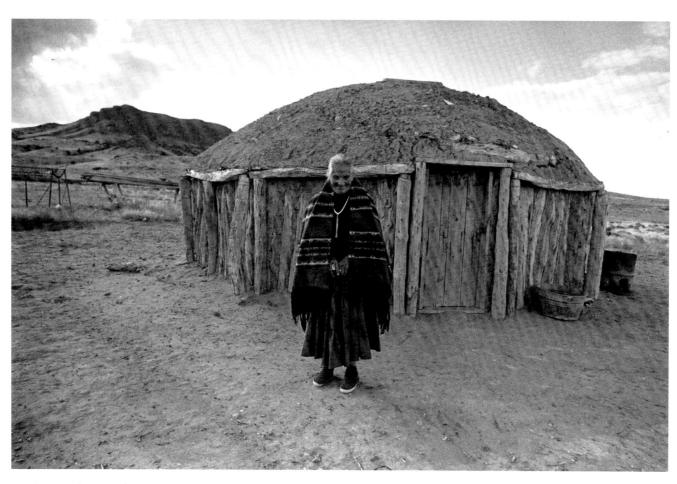

"This making a hogan can take pretty long unless we have a lot of help. Sometimes our family and neighbors come to help out. Then the building goes pretty fast." - DELBERT BEGAY

THE HOGAN

"We use what is on

our land. If we have

lots of mud, we

make a mud hogan.

If we live close to

rocks, we have a

stone one, and if

we live close to

logs, then we have

a wood one. Most

of the time, people

will use a mixture of

THE HOGAN IS AN INTEGRAL PART OF THE NAVAJO CONNECTION to the land; it represents a piece of personal property and consists of natural elements such as wood, stone, and mud. Delbert Begay is in the process of building this hogan for his mother.

The skeleton of the half-finished hogan stands in a field of sage. Delbert's twenty-year-old son,

Darrel, a college student, is home visiting the Begay camp. He points out a two-room house, a shed, and the partially built hogan, where six juniper posts remain upright and only part of the roof has been woven. The remaining logs and piles of mud clutter the base of the unfinished hogan.

Darrel explains, "This hogan is to be for my grandma. She is wanting a place of her own because our other house is getting too crowded, so we started to build this one for her.

"My dad and I started this hogan a while ago. To build a hogan, we have to clear the land to make it flat." He motions to the floor of his grandmother's hogan. "Then we get together all of the wood we need to build the hogan. We cut our logs in a forest not too far from here and bring them back to the camp. We have to start getting pretty picky when we choose the logs.

We take only the big, fat cedar [juniper] for our walls. Once we get only the good wood, we trim

them and make them square on the ends and sides.

Before we build, we always check to make sure we have enough logs for the roof and walls.

"We use what is on our land. If we have lots of mud, we make a mud hogan. If we live close to rocks, we have a stone one, and if we live close to logs, then we have a wood one. Most of the time, people will use a mixture of rock, log, and mud.

Our land has a little bit of everything.

"After the logs are readied, we put six posts in a circle. We make sure that the posts are about five to six feet apart. I usually walk about five or six steps to mark a spot for each post. Then we put stringer posts between the six standing ones. This is the start of the roof.

"To make the roof, we take logs with different lengths. We measure this wood with a rope to make sure each log is the right size. My cousins and uncles help with the roof. We pick up the logs and hand them to the roof-makers. Only the men with lots of experience must do the roof. You don't want the ceiling too low or too high. Too much weight can make the log walls crack, and too many logs can

make the roof too heavy. We lay the logs across each other, making a circle that looks like an upside-down basket.

"This making a hogan can take pretty long unless we have a lot of help. Sometimes our family and neighbors come to help out. Then the building goes pretty fast. "After the roof, we do the walls. We use fat cedar and cut the ends so they will fit the main posts. We build the logs around the posts, so they fit one on top of the other. We don't worry about the holes in the walls. We can always patch them up with wood chips, juniper bark, or rags and cover them with mud. I like to make the walls as tall as I am. The wall facing east is always shorter. This makes room for the door hole. Our doors face east so we can say hello to the sun.

We trim up the doorway and make it neat. We get a wooden door to put over the opening. Some people in the old days used a buckskin or rug to cover the door hole.

"Next, we close up the hogan nice and tight. Once the holes are filled, we cover the roof with our juniper bark. We call this Navajo tar paper. We take these wide strips and lay them across the top, and then we pile on the wood chips. We shovel them up really high, so they reach the rooftop.

asked the Holy "Then we put on the finishing People to build a touches. We have to cook the dirt and put it between the cracks in the walls, hogan made of white and we cover the roof with it, too. shell and abalone. First, we make a big fire, and we take a big washtub, fill it with water, and put it on the fire to boil. When the water is pretty hot, we add the dirt and stir it into mud. I guess you could also call this plaster. I take this mud, and I stand about a foot from the walls, and I throw the mud into the cracks. Then I rub the mud in with my fingers, so it becomes smooth and even. It also gets kind of messy.

"After we do the walls, then we do the roof. We use only the best heavy dirt and mud. We throw the mud up high and cover the roof. It takes long, and we have to do it right. If we don't, we have problems. When it snows, we might have a surprise in the morning of water dripping on our heads. When this happens, we have to redo the clay, cover the holes, and fix it right. Sometimes we even put down plastic in bad weather. We hold it down with rocks, which keeps the roof dry and us dry.

"We take oil drums and cut them in half to

The hogan is

important for

material reasons, but

also has significant

religious meaning.

The first hogan

was included in the

Navajo creation

story: First Man

and First Woman

be a stove. If you look up in this hogan, you will see a hole left. We would run a pipe from the stove up high to the hole. This is our chimney. The oil drum is a cook stove and a fireplace.

"Once we put in the oil drum, we are pretty much ready to move in. We check the walls and the roof to make sure everything is tight. Then we can move in our furniture: a couple of beds, a chest of drawers, shelves, clothes, kitchen stuff. It feels good to move into our new home."

The hogan is important for material reasons, but also has significant religious meaning. The first hogan was included in

the Navajo creation story: First Man and First Woman asked the Holy People to build a hogan made of white shell and abalone. Traditionally, the doorway of all hogans faces east to greet the morning sun of Father Sky. The inside of the hogan is a symbolic representation of Mother Earth's womb. These beliefs have been passed down through the generations, and the wood, rock, and mud continue to encircle Navajo people in a protective manner.²⁶

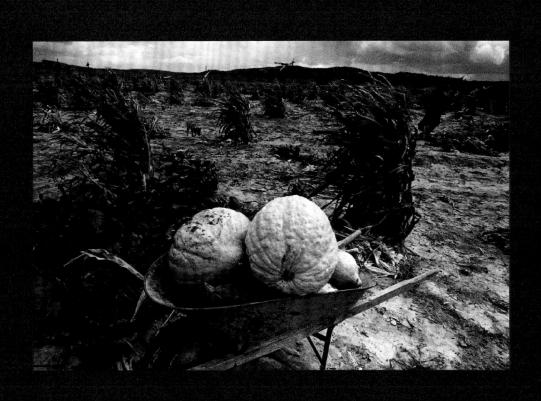

ACKNOWLEDGMENTS

When I first began the research for this book in the 1980s, I knew little of Navajo traditions and lifeways. Even though I was an outsider, The People shared parts of their world with patience and kindness.

Helen, my project partner and photographer, accompanied me on all excursions. Sometimes we had to leave at three o'clock in the morning. Helen was awake, packed, and ready to go. When we began this project, I was anxious. Helen was reassuring and full of encouragement. To Helen's memory, I offer my heartfelt thank you.

My Navajo friend and fellow teacher Danny Blackgoat gave much to this project. He participated in the book and arranged many meetings with his mother, Roberta. Sally Worker asked her parents, Stella and Sam, if we could visit in their home. The Deal family introduced us to Hazel Nez, Mary Joe Yazzie, and Oskar Whitehair. Manuel Shirley from Dilkon, Arizona, brought us to the home of Yazzie and his mother, Addie. Alice Spencer contacted her mother-in-law, Mary, for us. Steven Darden, the first Navajo to serve on the Flagstaff City Council, read an early version of the manuscript and offered words about Mother Earth and Father Sky for publication. Without these people, this project would not have been possible.

My husband, Bill, and daughter Megan were patient as I wrote and rewrote this book. I thank them for their tolerance and support. I do not know who among us was happiest to have it completed.

Many others helped with the first edition. I would like to thank them by name. Ann Rice Campbell, Lois Raney, and Barbara Twitchell encouraged me to begin writing. Ellen Allen, Nancy Bene, Linda Besnette, Letty David,

Mary Beth Green, Megan Hooker, Jan Koons, Ann Kramer, Frances Short, Lois Thompson, Paul Tissler, Tim Varner, Ann Walka, Ursula Wallentine, Kay Whitham, Judy Yescalis, and Pam Young-Wolff shared their knowledge, materials, and support. Bob Koons helped to obtain a grant so that the original project could be completed. Bud Greenlee assisted me in understanding my motivation behind the book. Lulu Santa-Maria believed in this project and helped with marketing the first edition. David Young-Wolff processed many of the photographs for that edition.

Jean Zukowski-Faust spent hours with me as I wrote and rewrote. Our best working times were in the evenings. I would arrive at her home at nine o'clock and would not leave until one or two in the morning. Jean understood even better than I my love for the Navajo people and allowed me to discover this on my own. Her support, encouragement, and, most importantly, her honesty enabled me to create this book.

For this third edition, Dr. Abraham Springer provided his expertise regarding the plants, water, wood, animals, and soil of the Navajo Reservation, and Susan Hobbs applied her knowledge of syntax. Raechel Running gifted a beautiful portrait of her mother, Helen.

And finally, I am grateful to Julie Hammonds and Myles Schrag of Soulstice Publishing, who understood the importance of preparing a new edition of this work. We Walk the Earth in Beauty witnesses how the Diné belong to their Mother Earth and Father Sky, aligning with Soulstice's mission of publishing "books with soul."

A TRIBUTE TO HELEN LAU RUNNING

One summer morning in 1979, I knocked on the door of the Running Photo Studio. Friends had encouraged me to reach out to Helen Lau Running, a photographer who had connections with Navajo people living on the reservation. I introduced myself, and she invited me in.

We sat with mugs of tea as I told her my vision of wanting to document the Diné as they lived their traditional lifeways. I put forth the idea of her photographing people grinding corn, branding cattle, and making moccasins. She listened intently and quickly responded, "All right, Kathy, let's do it." I was relieved that no convincing was needed. She carried my same vision and understood the importance of preserving traditional Navajo culture.

We became instant friends. Spending hours in my Jeep, we drove to and from the reservation, and our time together turned into a blessing. We discussed the thrill of upcoming interviews and photo shoots with The People as we drove to Navajo camps to witness the "old ways." Our return trips to Flagstaff were full of lively discussions about our time with Navajo families. Never experiencing a lull in our conversations, we spoke with great enthusiasm about what we witnessed, and we never had a cross word during our twelve-year journey.

Helen was a driving force in this project. Her many contacts propelled us in locating more Navajo people who were willing to show us their traditional lifeways. The Diné could sense her respect as she photographed them. Her warmth and grace traveled with her constantly, whether in the Jeep with me or in her interactions with our contacts. Her photographs capture the dignity and spirit of Navajo people as they live day to day with Mother Earth.

I will always cherish my time with Helen. When she passed in 2014, my heart sank. Even though she is no longer with us, her spirit, warmth, and kindness live on.

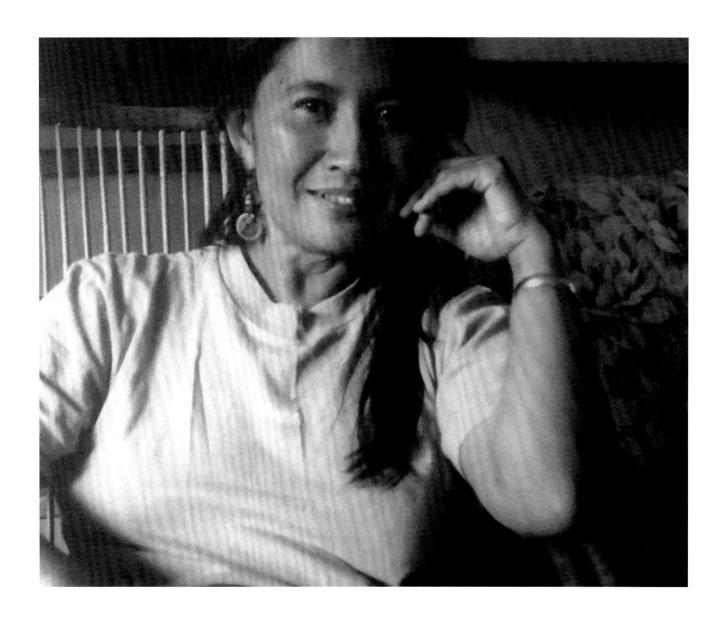

LIST OF PLATES

Navajo elder, Sebá Dalkai.
Herding sheep and goats, Cedar Ridge.
Bruce Spencer digging yucca root, Castle Butte.
Yucca root near Castle Butte.
Mary Spencer and granddaughter Lisa using yucca shampoo, Castle Butte.
Mary Spencer and granddaughter Lisa, Castle Butte.
Stella Worker holding a <i>bé'ézó</i> , Leupp.
Roberta Blackgoat with a pan of corn, Big Mountain.
Roberta Blackgoat winnowing corn, Big Mountain.
Roberta Blackgoat with cornmeal patties, Big Mountain.
Stella Worker carrying a pot of Navajo tea, Leupp.
Roberta Blackgoat hauling water, Big Mountain.
Ella Deal planting beans, Hard Rock.
Ella Deal harvesting melons, Hard Rock.
Ella Deal storing melons in root cellar, Hard Rock.
Danny Blackgoat carrying juniper, Big Mountain.
Oskar Whitehair's corral, Cactus Valley.
Summer shelter, Dilkon.
Stella Worker's new moccasins, Leupp.

- Page 51. Percy and Christine Deal pass the branding iron, Hard Rock.
- Page 53. Deal family branding, Hard Rock.
- Page 55. Herding, Cedar Ridge.
- Page 57. Sheep's wool, Cedar Ridge.
- Page 59. Roberta Blackgoat preparing a butchered goat, Big Mountain.
- Page 61. Roberta Blackgoat preparing stuffed liver, Big Mountain.
- Page 62. Roberta Blackgoat kneading dough, Big Mountain.
- Page 65. Roberta Blackgoat preparing fry bread, Big Mountain.
- Page 68. Hazel Nez shearing a sheep, Dinnebito.
- Page 71. Hazel Nez washing wool, Dinnebito.
- Page 73. Hazel Nez threading the loom, Dinnebito.
- Page 75. The hands of Hazel Nez, Dinnebito.
- Page 77. Hazel Nez, Dinnebito.
- Page 82. Mary Joe Yazzie preparing clay for pot-making, Cow Springs.
- Page 85. Firing a pot, Cow Springs.
- Page 88. Addie Yazzie's mud oven, Dilkon.
- Page 90. Traditional hogan, Sebá Dalkai.
- Page 93. Autumn harvest of squash and melons, Hard Rock.

NOTES

- 1. Zora Getmansky Hesse, Southwestern Indian Recipe Book, (Parker Lake: Filter Press, 1973), iii.
- 2. Laura Gilpin, The Enduring Navajo, (Austin: University of Texas Press, 1975), 124.
- 3. Michael Brent, "The Uses & History of the Yucca Plant," (ehow.com, undated, accessed January 15, 2024), https://www.ehow.com/info_8445167_uses-history-yucca-plant.html.
- 4. Clyde Kluckholm, *The Navajo*, (Cambridge: Harvard University Press, 1946), 47, 49.
- 5. "Selected Plants of Navajo Rangelands" database, (New Mexico State University, undated, accessed January 15, 2024), https://navajorange.nmsu.edu/
- 6. Subhuti Dharmananda, "Greenthread: Navajo Tea," (Institute for Traditional Medicine, January 2004), itmonline.org/arts/greenthread.htm.
- 7. Lela Nargi, "For Navajos, Desert 'Tea' Fosters Kinship With Heritage And Nature," (National Public Radio, August 29, 2017), https://www.npr.org/sections/thesalt/2017/08/29/546817827/for-navajos-desert-tea-fosters-kinship-with-heritage-and-nature.
- 8. John Barrat, "Corn Entered Southwest U.S. First Along Highland Route, DNA Shows," (*Smithsonian Insider*, February 24, 2015), http://insider is.edu/2015/02/corn-entered-southwest.
- 9. Jani C. Ingram, "Uranium and Arsenic Unregulated Water Issues on Navajo Lands," (Journal of Vacuum Science and Technology A, May 2020), https://www.ncbi.nim.nih.gov.
- 10. Matthew L.M. Fletcher, "As Drought Persists in the West, Justices to Consider Navajo Nation's Rights to Colorado River," (scotusblog.com, published March 17, 2023), https://www.scotusblog.com/2023/03/as-drought-persists.
- 11. Navajo Nation Department of Water Resources (website), accessed January 15, 2024, https://nndwr.navajo-nsn.gov.

- 12. Mitchell, Rose, Tall Women, (Albuquerque: University of New Mexico Press, 2001), 35–37.
- 13. Sam and Janet Bingham, Navajo Farming, (Logan: Utah State University, 1979), 6.
- 14. "Pinyon-Juniper Woodlands," (National Park Service, accessed January 15, 2024), https://www.nps.gov/articles/pinyon-juniper-woodlands-distribution.htm.
- 15. "The Indomitable Juniper," (National Park Service, accessed January 15, 2024), https://www.nps.gov/cany/learn/nature/utahjuniper.htm.
- 16. Enduring Navajo, 123.
- 17. Peter Iverson, Diné, (Albuquerque: University of New Mexico, 2002), 23.
- 18. Ibid, 23-24.
- 19. Enduring Navajo, 123.
- 20. "Sheep and Wool," (Chimayo Weavers, accessed January 15, 2024), https://www.chimayoweavers.com/pages/sheep-and-wool.
- 21. "Navajo's Courage Keeps Her Rooted for Decades," (*Los Angeles Times*, February 5, 2006), https://www.chicagotribune.com?news?ct-xpm-2006=02-05.
- 22. Book of the Navajo, 13.
- 23. Ibid.
- 24. The Navajo, 87.
- 25. Ibid., 89.
- 26. Book of the Navajo, 15.

SUGGESTED READINGS

Bingham, Sam, and Janet Bingham, *Navajo Farming*, Chinle: Rock Point Community School, 1979.

Gilpin, Laura, *The Enduring Navajo*, Austin: University of Texas Press, 1975.

Hesse, Zora Getmansky, *Southwestern Indian Recipe Book*, Palmer Lake: The Filter Press, 1973.

Hooker, Kathy Eckles, and David Young-Wolff, *Voices of Navajo Mothers and Daughters: Portraits of Beauty*, Flagstaff: Soulstice Publishing, 2022.

Iverson, Peterson, Diné, Albuquerque: University of New Mexico, 2002.

Kluckholm, Clyde, and Dorothea Leighton, *The Navajo*, Cambridge: Harvard University Press, 1974.

Locke, Raymond Friday, *The Book of the Navajo*, New York: Kensington Publishing Corp., 2001.

Scudder, Thayer, Expected Impacts of Compulsory Relocation of Navajos With Special Emphasis on Relocation from the Former Joint Use Area Required By Law 93-531, Binghamton: Institute For Development Anthropology, 1979.

Vankat, John L., *The San Francisco Peaks and Flagstaff Through the Lens of Time*, Flagstaff: Soulstice Publishing, 2022.

"Washing Wool with Yucca," *Tsá'á'szí*, Ramah, New Mexico: Ramah Elementary School, 1975.

ABOUT THE AUTHOR

Kathy Eckles Hooker was born in Palo Alto, California, and grew up in a Virginia suburb of Washington, D.C. Her introduction to Native American cultures began as a child watching Native dancers perform at the Department of the Interior.

Kathy attended The College of Wooster in Wooster, Ohio, and graduate school at Antioch College in Yellow Springs, Ohio. She and her husband, Bill Hooker, moved to the Navajo Reservation in the 1970s, where he practiced dentistry and she taught English to Diné students at Dilcon Boarding School.

Amazed at how the Diné honored and utilized their land, Kathy studied their traditional lifeways and from her research wrote this book. Later, she taught English at Flagstaff Unified School District for thirty-three years, where again she worked with Diné students. The result was a second book, *Voices of Navajo Mothers and Daughters: Portraits of Beauty*, in which 65 Navajo women in 21 families open up about how they have been shaped by powerful cultural, natural, and historical forces—and by their love for each other.

Kathy and her husband live in Flagstaff, Arizona. The couple has two adult daughters.

ABOUT THE PUBLISHER

Soulstice Publishing brings to life "books with soul" that inspire readers with stories of human potential realized and celebrate our unique position in the Southwest.

Soulstice took root in our mountain town of Flagstaff, Arizona, which sits at the base of the San Francisco Peaks, on homelands sacred to Native Americans throughout the region. We honor their past, present, and future generations, as well as their original and ongoing care for the lands we also hold dear.

Surrounded by ponderosa pines, enriched by diverse cultures, and inspired by the optimistic Western spirit, Flagstaff abounds with scientists, artists, athletes, and many other people who love the outdoors. It is quite an inspiring place to live. Considering the dearth of oxygen at our 7,000-foot elevation, you might say it leaves us breathless.